IMAGES
of America

NOBLESVILLE

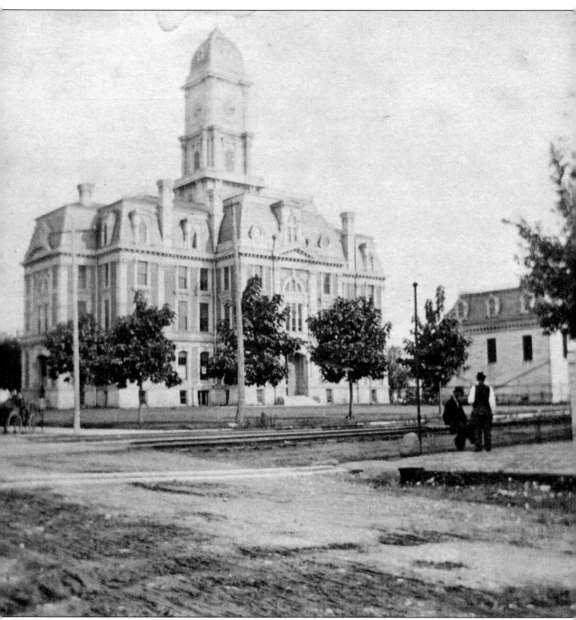

County commissioners began planning for this courthouse in March 1877. The cornerstone was laid on April 20, 1878, but construction was not completed until July 1879. This photograph shows the west side of the building, which replaced the small brick courthouse of 1838. Note the rear of the old jail on the right. This new courthouse was, and still is, a landmark of Noblesville and Hamilton County. (HCHS–Richardson Collection.)

ON THE COVER: This photograph shows the float that the Noblesville Milling Company designed for the 1923 centennial parade. It sits outside the office of the milling company, ready to move into position for the parade. Nordyke and Marmon, owner of the local milling company, was first known internationally as an outstanding builder of milling equipment. The Noblesville facility was originally operated as a "model mill" to showcase the latest improvements in milling. (HCHS.)

IMAGES
of America
NOBLESVILLE

Nancy A. Massey and Carol Ann Schweikert

ARCADIA
PUBLISHING

Published by Arcadia Publishing
Charleston, South Carolina

Printed in the United States of America

Library of Congress Control Number: 2011928973

For all general information, please contact Arcadia Publishing:
Telephone 843-853-2070
Fax 843-853-0044
E-mail sales@arcadiapublishing.com
For customer service and orders:
Toll-Free 1-888-313-2665

Visit us on the Internet at www.arcadiapublishing.com

*This book is dedicated to the residents of
Noblesville: past, present, and future.*

CONTENTS

ACKNOWLEDGMENTS

A book of this scope is not possible without the help of many. We would like to thank all those who provided images for use in this book. Without your generosity, enthusiasm, and support, this book would not exist. You share our desire to preserve Noblesville's past for future generations.

Special thanks are extended to all the following individuals and organizations who have given their time, photographs, histories, and moral support for this book: Boys & Girls Club of Noblesville, First Christian Church, First Friends Church, First Presbyterian Church (FPC), First United Methodist Church (FUMC), Hamilton County Historical Society (HCHS), Hamilton County Surveyor's Office, Hamilton East Public Library (HEPL), Noblesville Fire Department, Noblesville Free Masons, Noblesville Parks and Recreation Department (NPRD), Noblesville Police Department, Noblesville Schools, Robert Arbuckle, Terry Bentley, Joe Burgess, Jane Campbell and family, Thelma Clark, Charlie Connett, Stephen Craig, Larry and Judy Driver, Paula Dunn, John Elliott, Sherry and Ray Faust, Jane Cullen Gawthrop, Esther Goodwin, John Green, the Hare family, Irv Heath, Kay Heiny, Gerry Hiatt, Hubert Hill, Luke Kenley, Nancy Kenley, Pat Logan, Joan Love, Ruth Hall Lusher, the Metsker family, Kurt Meyer, M. IvaLou Millikan, Margaret Musgrove, Mel Pearson, Don Roberts, Heather Roudebush, Mary Sue Rowland, Steve Schwartz, Ellen Swain, Fred Swift, Dale Unger, Dave Wallace, Pauline Wease, and Dottie Young.

We want to thank those who helped us in working on the book. A debt of gratitude goes to Paul BeDell for teaching Nancy how to scan photographs to prepare them for the book. Special appreciation goes to our proofreading team for their time and knowledge of Noblesville: Mike Corbett, Paula Dunn, Irv Heath, Kurt Meyer, Diane Nevitt, and Dottie Young. Special thanks also go to Sherry Faust and Paula Dunn for their time, help, footwork, and support in researching photographs.

Last but not least, special thanks go to our families for their support and encouragement in this endeavor.

In the course of working on this book we encountered five wonderful ladies who gave us their time, photographs, and support but who did not live to see the final product. This book is dedicated in loving memory of Jane Campbell, Phyllis Dye, Pat Logan, Jerry Snyder, and Pauline Wease.

INTRODUCTION

Settlers seeking a new place to call home found the east bank of the west fork of the White River to be ideal. When these early pioneers arrived in the area that is now Noblesville, they found dense forests of hardwood trees. It was a monumental task to cut down the trees, build log cabins, and prepare the land for planting. Besides growing food to eat, farmers planted corn and wheat, hauling the surplus grain to Cincinnati markets (which was not always cost effective). Despite these obstacles, agriculture became the county's main source of wealth for many years, establishing Noblesville as a farming community.

In January 1823, William Conner and Josiah F. Polk laid out the village of Noblesville. The courthouse square was bounded by Conner Street on the south, Catherine (now Ninth) Street on the east, Logan Street on the north, and Polk (now Eighth) Street on the west. Since the original plat, other street name changes include Wiltshire to Maple, Emmaus to Cherry, and Anderson to Tenth, as seen on the plat map on page 9. In March 1824, Noblesville officially became the county seat of Hamilton County, Indiana. In that same year, a post office was established with Josiah F. Polk as the first postmaster.

There are two stories of how Noblesville came to be named. Most likely, it was named for James Noble, a US senator from Indiana. However, local legend says the town was named in honor of Josiah Polk's fiancée, Lavina Noble. As the story goes, Josiah built a house for his bride-to-be in the center of town, planting a garden of vegetables in such a way that it spelled out his beloved's name. Josiah felt this act symbolized his deep love for Lavina. However, Lavina felt differently and broke off the engagement. Although people enjoy telling the local legend, most feel Senator Noble is a more suitable person to honor.

Mills were erected to grind wheat and corn into flour and cornmeal, which were used to make bread. Noblesville Milling Company was one such enterprise. Also known as the Model Mill, the building was considered one of the best-equipped mills in the country. In 1925, company manager C.B. "Pop" Jenkins bought sports uniforms for Noblesville High School and the Noblesville Black and Gold became the Noblesville Millers in appreciation of his generosity.

The first railroad to run through Noblesville was the Peru and Indianapolis Railroad in 1851, which allowed farmers to effectively send their surplus crops to market. That same year, Noblesville became incorporated as a town with David Moss as the first mayor. Adopted in 1853, the town seal depicted a sheaf of wheat surrounded by the words "Seal of the Corporation of Noblesville."

As transportation routes progressed from the original Indian trails, there came toll roads, railroads, and the Interurban; there also very nearly came the Central Canal. When construction began in 1836, the Central Canal was planned to run through Noblesville. Working with axes, shovels, horses, and wagons, workmen came to clear the trees and dig a 40-foot-wide canal bed. Unfortunately, the state went bankrupt, stopping all work in 1839. All that remains of the work is a remnant of the canal bed and a historical marker off 191st Street.

In the early days, when few stores existed, people bartered for goods and services. In 1850, there were 664 people in the town. By 1870, the population increased to 1,435. In the township, the population grew from 2,308 to 3,568 those same years. Small stores were built around the square to provide goods and services for the growing community.

The discovery of natural gas in 1887 was a significant boost to Noblesville's economy and population. Industries sprang up quickly, since factories could operate inexpensively on this seemingly endless supply of natural gas readily available in wells all around the county. Also in 1887, Noblesville became incorporated as a city with Edgar C. Wilson as the mayor. The gas boom exploded, changing the face of the community from farming to business and industry with a new city seal featuring a gas well in place of the sheaf of wheat.

By the turn of the 20th century, Noblesville was teeming with merchants. The small frame stores were replaced with substantial brick buildings. Gran'pa's Popcorn and Candy Store reputedly served the first ice cream cone in Noblesville in 1905. Although the gas boom abruptly ended in 1910, the industries and new businesses stayed, and growth continued. Some firms closed their doors, while others remained as fixtures for many years. The oldest Noblesville business is still in operation—W. Hare and Son began with buggies and moved on to automobiles, becoming Hare Chevrolet. Firestone Industrial Products expanded local industry in the 1930s but closed in 2009. Many businesses survive now only in memories and photographs.

The public square of Noblesville was the center of community life beginning with the courthouse and jail. The Carnegie Library appeared in 1913 just off the square. The fire department, with its 1935 fire engine, watched over the buildings while city hall provided space for Noblesville city government to function. Before Riverview Hospital, Harrell Hospital and its nursing school headed by Dr. Samuel Harrell served the medical needs of Noblesville residents.

As hard as the people worked, they sought entertainment and recreation in the Chautauquas, parades, musical concerts, clubs, Forest Park, and a nearby resort area named Riverwood. Chautauquas provided educational entertainment each summer from 1910 to 1926, when Forest Park opened to provide a place to just relax and play. Club bands and the Noblesville Military Band marched in parades and gave concerts. Riverwood was popular in the summer as a place to swim in the river and escape the bustling city. Entertainment venues erupted with the arrivals of the Wild Opera House in 1895 and the Olympic Theatre in 1920.

In March 1913, severe storms blew in from the northwest causing the Flood of 1913, which dramatically threatened life in Noblesville. The river crested nine feet over the flood stage, effectively cutting off Noblesville from the rest of the county. No other local flood has ever equaled the extent of its destruction and terror.

The construction of township schools peaked in the 1890s and early 1900s, but they closed one by one as students were transferred to the emerging city ward schools. The first city schools were a frame building, a brick building on Logan Street, and the "colored" school. The county seminary was built in 1847.

Churches were the heartbeat of the community from the early days of the settlement. Services were often held in homes or businesses until a dedicated structure could be erected to meet the needs of growing congregations.

The following chapters, through the history of Noblesville's people, buildings, and events, trace the growth of this once-small town into the city it is today.

One

IN THE BEGINNING

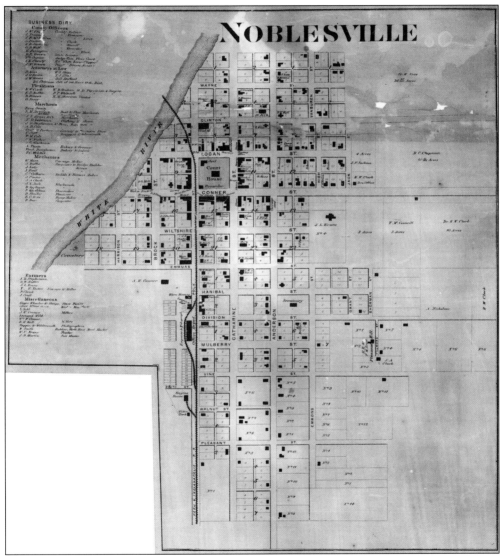

This 1866 plat map shows the growth of Noblesville since 1823. The bridge over the river is for the Peru & Indianapolis Railroad. Until the Old Wagon Bridge (Logan Street Bridge) was built, the townsfolk ferried across or forded the river. The original 1866 map belonged to Nailer W. Webster, a Civil War veteran. The map was compiled from "actual surveys" and drawn by Carl S. Warner. (Hamilton County Surveyor's Office.)

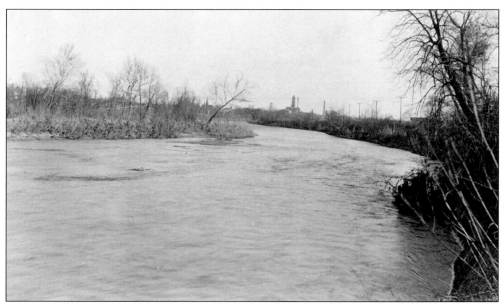

Noblesville was founded on the east bank of the White River. Pioneers settling in Hamilton County found this west fork of the White River an ideal place to call home. The river flowed clear and cool through a hardwood forest, with plenty of fish to catch. In this photograph, the courthouse can be seen in the distance. (Gerry Hiatt from the Reed and Steve Miller Postcard Collection.)

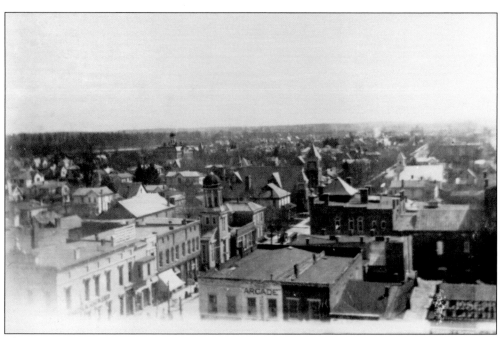

This early 1900s photograph shows Noblesville from the top of the county courthouse. Looking south, the Wild Opera House is on the right side of Catherine (now Ninth) Street and the First Presbyterian Church (multi-sided tower) is on the left. Farther south on Catherine Street is the First Christian Church, on the left. The cupola visible in the distance sits atop Second Ward School. (FPC and Irv Heath.)

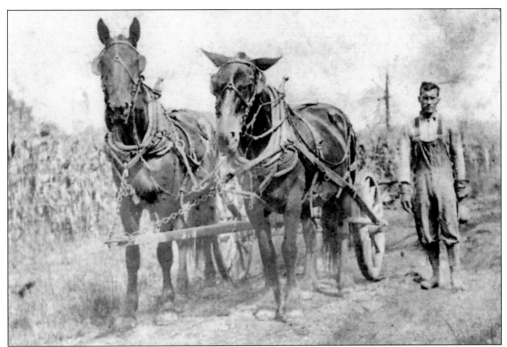

The roots of Noblesville, as well as of Hamilton County, are deep in the land. When pioneers first settled, they found the area covered in woods. To farm, they cut down the trees and began working the rich soil. Corn was the main crop and, for the most part, remains so today. Wheat was also grown. Farming was hard work; above, Harry Hall plows his fields using a team of strong mules. By the 1920s, land was still being farmed but tractors were beginning to replace mules and a plow. The photograph at right shows how, in time, Harry began using a tractor. From left to right are Naomi, John, Neva, baby Gene, and Harry Hall. (Both, Ruth Hall Lusher.)

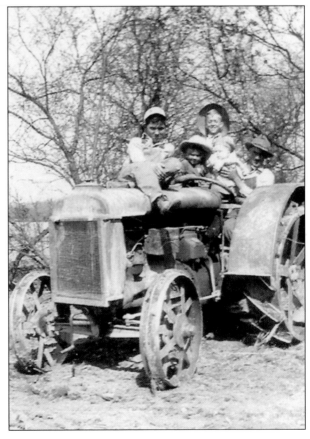

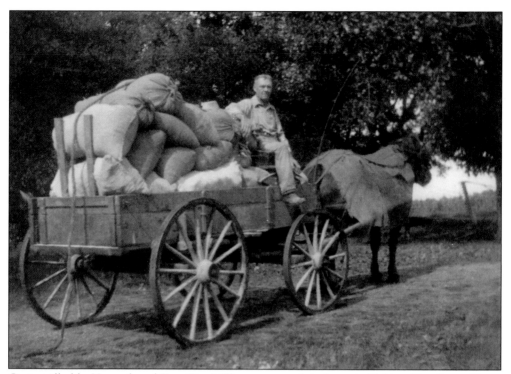

Grain mills, like Haworth and Sons City Mills, were an early industry in Noblesville, often utilizing water from the White River to operate. Farmers brought their harvested corn and wheat to town to be ground into cornmeal or flour. From 1887 to 1907, mills used natural gas. When the gas was exhausted, mill owners switched to electricity. In this image, Hamilton "Ham" Metsker and his mule Old Frank are taking grain to one of the mills in Noblesville. (Metsker family.)

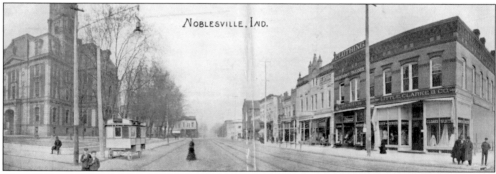

This 1900s postcard view of Noblesville looks up North Catherine Street. On the left is the courthouse, and on the right are commercial buildings constructed during and just after the gas boom of 1887. The Little, Clarke & Company dry-goods store is on the corner on the right. Tescher Clothing and the Wild Building are next door. At this time, the downtown business district was the heart of the city, with nearly all Noblesville businesses located there. (HCHS–Richardson Collection.)

Two

READIN', 'RITIN', AND 'RITHMETIC

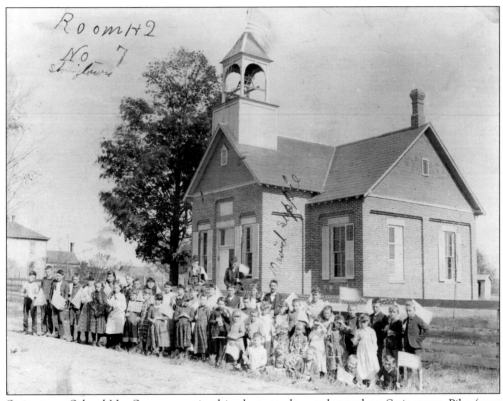

Stringtown School No. Seven, seen in this photograph, was located on Stringtown Pike (now Hague Road) in Noblesville Township. The schoolhouse was built in 1890 by trustee John Wallace and closed in 1925. By the 1980s, the building was crumbling and falling apart. David Supple (pictured here in the back row under the handwritten name, along with his students from room two) was a teacher for more than 30 years beginning in 1867. He came from New York City on the orphan train in 1859 as a 12-year-old, along with a number of other orphan children including his sister Catherine. He was highly respected and well known in Noblesville and throughout the county, serving as justice of the peace. A sign outside his office read "David Supple, justice of the peace. Marriage solemnized with neatness and dispatch." He died in 1912, twelve years after this photograph was taken. (HEPL.)

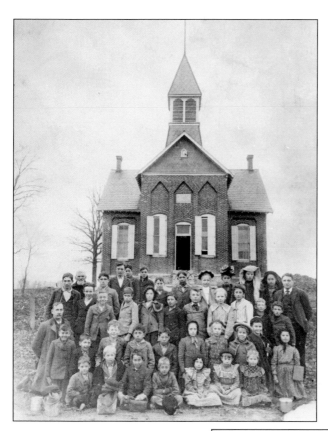

This photograph shows Baton Rouge School No. Eight, built in 1893 by trustee William T. Wheeler. Located in one of the oldest districts in Noblesville Township, this one-room school was the third building for this district, replacing earlier frame structures. Although the school closed in 1930, the structure still stands, serving as a private residence. (Larry and Judy Driver.)

This 1920s photograph shows Little Chicago School No. Two, located on State Road 38. Built in 1889, it replaced the original frame schoolhouse. The school was closed in 1941 by trustee Clyde Pettijohn. In November 1943, the property was sold to John Owen, whose farm surrounded the schoolhouse. The school bell was given to Florence Carey Horney, wife of the county surveyor Roy Horney, as her husband had attended Little Chicago. (HEPL.)

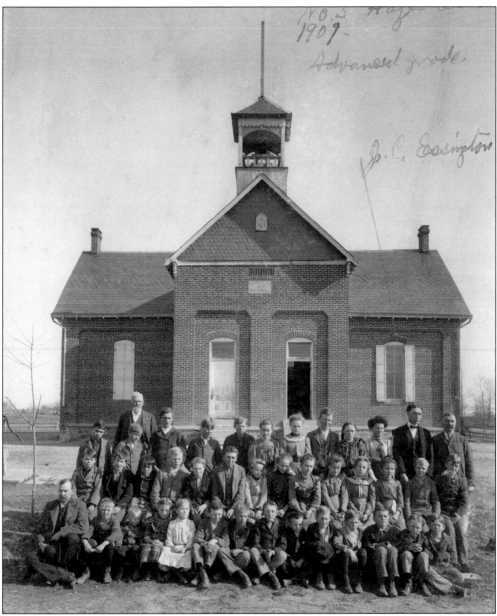

Hazel Dell School No. Three, featured in this photograph, is located on Hazel Dell Road south of State Road 32. This building had two entrances side by side, which led into separate cloakrooms. Inside, the school was divided into two rooms, with grades one through four in the smaller room and grades five through eight in the larger. Students in the upper grades attended the Noblesville city high school. The rooms were divided by sliding doors, which were attached to a pulley and could be raised to make one large room. The school closed in 1935 and subsequently served as the meeting place for the Hazel Dell Community Club. When the club disbanded after World War II, the building fell into disrepair until being renovated to house a gift shop. Ethel Mae Lennen (back row, third from the right) married Albert J. Hines, Hamilton County auditor, on April 19, 1902, two years after this photograph was taken. After teaching at Hazel Dell, she taught at Clay Center schools. She passed away on June 13, 1953. (HEPL.)

This photograph, taken in the 1920s, shows Rosebud School No. 10. This schoolhouse was a frame building (the only one in use in Noblesville Township at the time). Rosebud was located on East State Road 38 and was built in 1899 by trustee Walter Hunt. Rosebud closed in 1927 when attendance dropped below 12. It is now a private residence. (HEPL.)

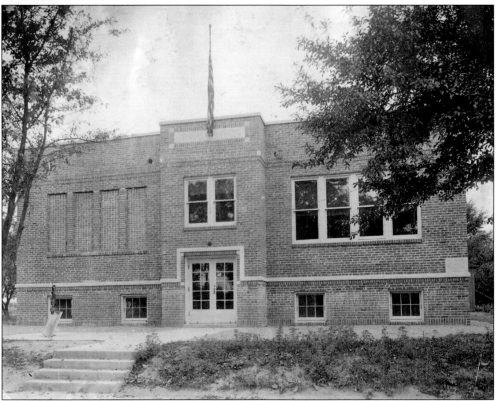

Currently used for offices, Federal Hill was the last township school built in Noblesville Township and was erected in 1917 by trustee Ellis A. Hutchens. It had an assembly room, two recitation rooms, an office, a cloakroom, a large room for manual training and industrial work, a coal room, a furnace room, two toilets, drinking fountains, and electric lights. When Forest Hill opened in 1961, Federal Hill closed its doors. (HCHS.)

This late 1890s photograph shows Noblesville Township teachers who had gathered for a meeting. From left to right are (first row) Nancy Martin, John Stern, Esther Smith, and Will Caylor; (second row) two unidentified, Billie Patterson, David Supple, and unidentified; (third row) Laura (Wheeler) Keiser, Albert Keiser, Marie (McConnell) Jerrell, and ? Stevenson. (HCHS.)

Photographed around 1900, this distinguished group is believed to be staff in Noblesville's school system. Among them are truant officer Andy Fryberger (first row, far right) and Superintendent John F. Haines (first row, second from left). In the 1870s, the schools employed a superintendent who taught along with five to six teachers. By 1897, there were 25 teachers. For many years, the school principals supervised the teachers while also teaching a grade or subject. (HEPL.)

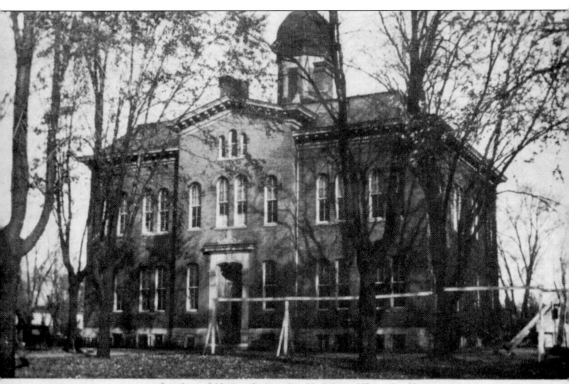

Junior High School, Noblesville, Indiana

Second Ward School, variably known as the high school, grammar school, or junior high school, was the first of the three ward schools constructed and the second school on the site now known as Seminary Park. Constructed in 1870–1871, it was designed by Indianapolis architects Enos and Hubner and cost just $21,000. From 1871 through 1888, students in first grade through high school were taught here, although the school was generally known as "the schoolhouse." In 1908, grades seven and eight were consolidated here with first-, second-, and sometimes third-grade students from the city's second ward. Improvements to the building include the installation of a dry closet sanitary system in 1890 and electric lighting in 1919. The cupola was removed between 1932 and 1950. Prior to its construction, the schools in Noblesville comprised a frame structure, a brick school on Logan Street, the "colored" school, and the seminary. The latter was demolished to make way for this building. (Gerry Hiatt from the Reed and Steve Miller Postcard Collection.)

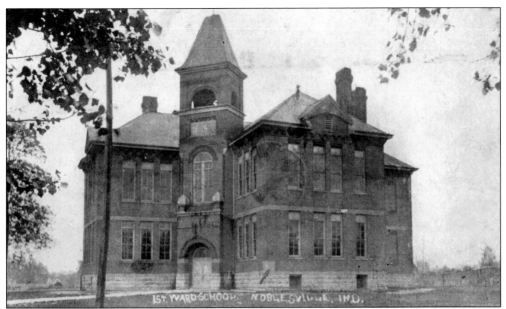

First Ward, built between 1888 and 1889, contained eight classrooms and was the second of the ward schools built in Noblesville. For much of its history, students in grades one through six attended classes here, walking to school from homes in the surrounding neighborhoods. Until 1908, seventh and eighth grades were also sometimes taught in this building. A fire in 1890 caused significant damage to several classrooms. Noblesville's first Parent-Teacher Association was organized here in 1914. (Heylmann family.)

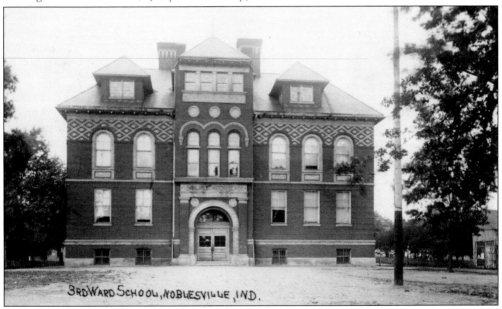

Constructed in 1892–1893 by Heinzman Bros., Third Ward was the last of the ward schools built in Noblesville. The school stood near the corner of South Tenth and East Christian Streets and housed grades one through four during its first year. Although the school expanded to include eighth grade, for most of its career, Third Ward taught grades one through six. In 1913, nine maple trees were approved for the school grounds. (HCHS.)

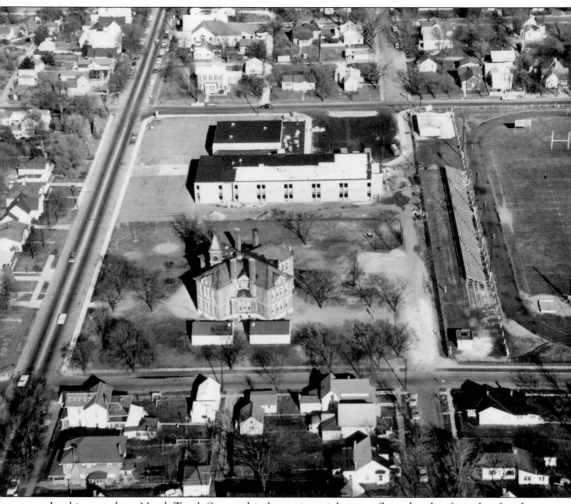

Looking north on North Tenth Street, this dramatic aerial view reflected reality for only a few short months in 1967, after North Elementary was completed and before First Ward was demolished. In 1889, the school system purchased the corner property where First Ward was built. In 1939, as the school board planned for future growth, it purchased the remainder of the block, known as The Commons, from Horace G. Brown for $11,000. Their development of this block began with the athletic fields, which are visible on the right. Called Memorial Field, these facilities were installed gradually in the 1940s because of the expense and the limitations established by the War Production Board during World War II. Prior to their installation, the school was without permanent athletic facilities. Football was played on Joseph Field, property on Noblesville's east side that was rented by the school system. Memorial Field was used until 1969, when new athletic facilities were installed near the high school. (Noblesville Schools.)

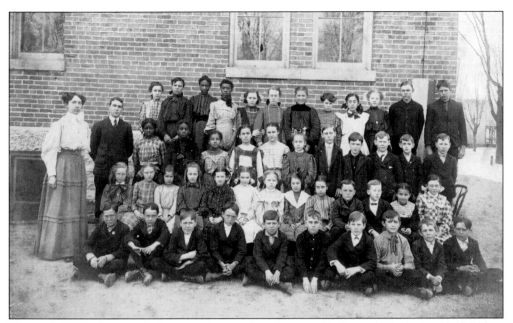

This early 1900s photograph shows students and teachers outside Second Ward when the building functioned as Noblesville's junior high school. Integration of the Noblesville schools occurred in June 1890. The school board voted to abolish the "colored" school in Noblesville and to admit its students to the graded buildings during the next school term, 1890–1891. Photographs throughout the school system document the integration at all grade levels. (HCHS–Richardson Collection.)

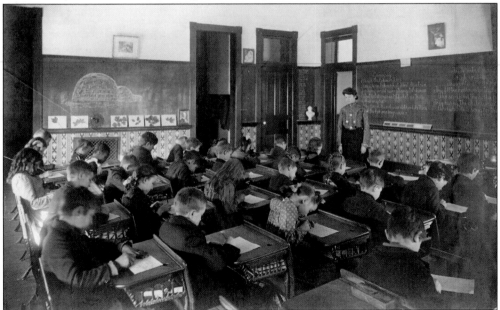

Reading, writing, and arithmetic have always been part of the curriculum in the Noblesville School system. Music was one of the first "specials" added to the school system, although it appears that just one music teacher was responsible for the entire student body. Taken January 14, 1904, this photograph reveals an elementary class at Third Ward studying Eskimos during a geography lesson. (HEPL.)

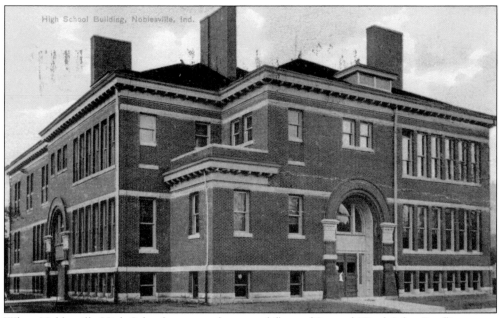

When Noblesville High School outgrew the second floor of Second Ward, John Durflinger was hired to construct a dedicated high school. Completed in the fall of 1900, the new facility on Conner Street contained eight classrooms, a chemical laboratory, and the superintendent's offices. Although the name was never officially changed, it was sometimes called Levinson High School during the 1910s, reflecting the Levinson family's support. The building was used as the high school for 54 years, and then as a junior high school until 1968. (HCHS.)

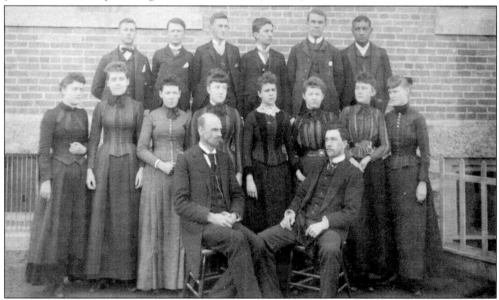

These 14 students made up the class of 1890 at Noblesville High School, and the photograph was captured outside the "old" schoolhouse (later called Second Ward). Seated with the students are Superintendent John F. Haines (front left) and teacher John C. Trent (front right). During this time, the high school staff comprised just two or three teachers who also had administrative duties. (HEPL.)

Although discussions concerning the need for a high school gymnasium had gone on for years, this facility was not completed until 1923. Designed by McGuire & Shook, Indianapolis architects, the design included a second story connector to the high school and space for manual training, domestic science, and commercial departments. The school board also had a permanent meeting location, the Levinson Room. (Gerry Hiatt from the Reed and Steve Miller Postcard Collection.)

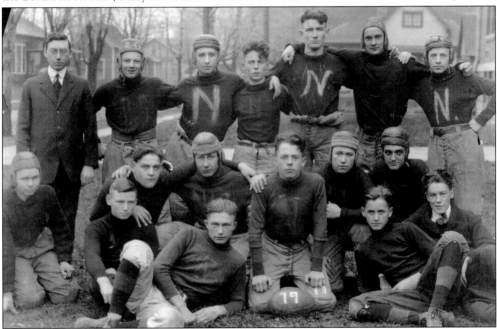

The 1919 football season was described in the yearbook as "the most successful season of any Noblesville High School football team in many years." In the five games they played, the team scored 93 points to their opponents' 19. Pictured in the team photograph, from left to right, are (first row, sitting/reclining) Alton Talley, Russell Williams, George Wheeler, and Eddie Faucett; (second row) Maurice McCoun, ? Hiatt, Victor Colburn, ? Walsh, Gifford Bradley, and Clarence Heiny; (third row) Roy L. Stockrahm (coach), Wayne Lyon, Lee Howell, John Stephenson, Floyd Heiss, Robert Clover (captain), and Frederick C. Pfaff. (Heylmann family.)

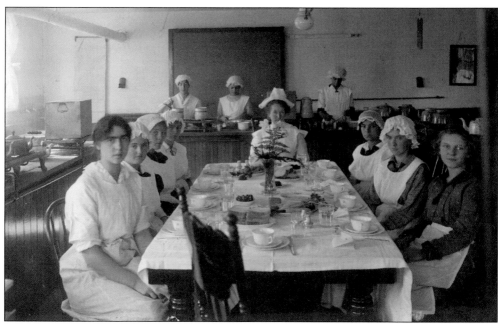

Preparing students for adult life has always been a key objective of public schools. In the 1900s, that objective often focused on preparing students for occupations. In 1908, the school board found it prudent to add manual training and domestic science to its high school courses. With limited funds, the board directed Superintendent Edwin L. Holton to introduce these subjects gradually and with restricted expenditures. The ladies seen in the photograph above appear to be attending a domestic science class, which was originally located in Second Ward. The group of young men below appears to have been enrolled in a woodworking class. When the gymnasium was completed, the facility included space for a shop class. In the 1910s, agriculture was added to the high school curriculum. (Both, HEPL.)

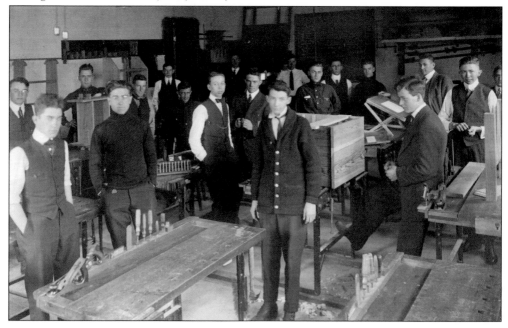

Three

OLD TIME RELIGION

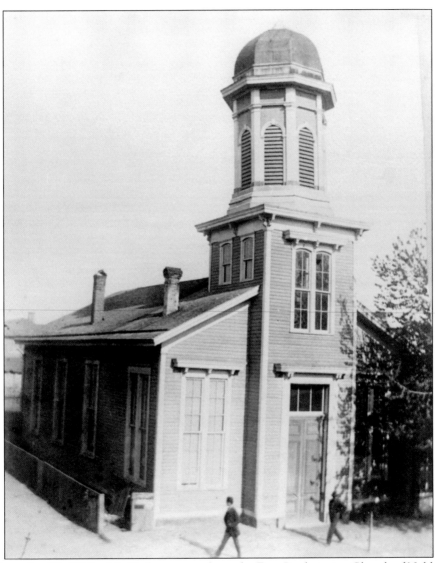

On December 20, 1848, with 11 charter members, the First Presbyterian Church of Noblesville was formed with William H. Rogers as the first minister. On July 27, 1850, land was donated for a church building by charter member Curtis Mallery and his wife Nancy. The Greek Revival–style frame church, shown in this photograph, was erected on the donated lot on the east side of Catherine (now Ninth) Street. (Irv Heath and FPC.)

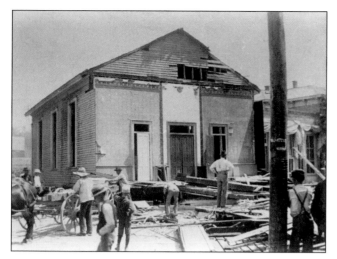

In 1868, Rev. John Sawyers Craig (often called "Father Craig") began his 17 years of service as pastor of the First Presbyterian Church in this frame church building. The Church of the Brethren bought the building, moving it to the northeast corner of Twelfth and Grant Streets. During the move, the tower fell to the street. In 1945, the Catholic Church bought the building and moved it to Eleventh Street, where it was razed in 1973. (FPC and Irv Heath.)

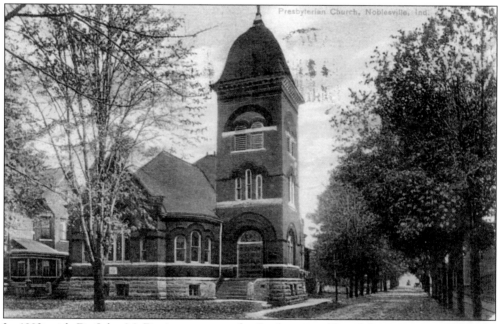

In 1893, with Dr. John M. Davies as pastor, the Presbyterian Church began construction of a new brick church building in the Romanesque Revival style. The site, donated by William H. Craig, was on the southeast corner of Twelfth and Conner Streets. The design was patterned after a church in Elgin, Illinois. The house next door, which had been built by Craig, came into the possession of the church many years later. (FPC.)

Rev. Gwilym E. Jones began his ministry on April 13, 1927, serving until September 25, 1938. This 1931 photograph shows Reverend Jones (on the left) with the church choir. Note the electric lights arching above the organ pipes. The stenciling just above the wood paneling was painted over in 1966, but was replicated when the church was redecorated in 2003. (FPC.)

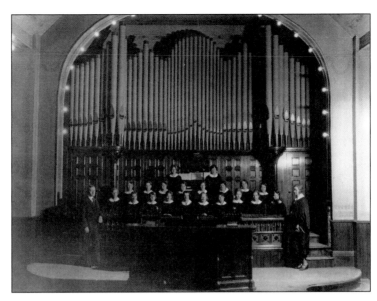

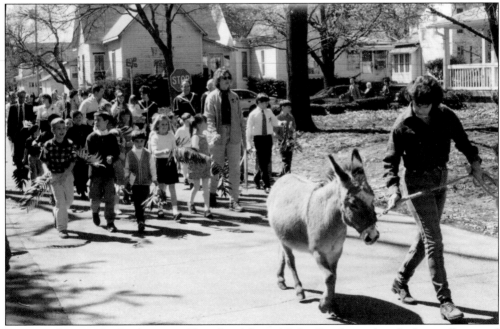

For several years, the Presbyterian Church celebrated Palm Sunday with a donkey walk around the block. During the last hymn of the worship service, the choir and the children walked down the aisles and out of the church carrying palm branches. This photograph shows Susan Moran leading a Sicilian burro named Lora in a donkey walk on Palm Sunday, March 29, 1998. (FPC.)

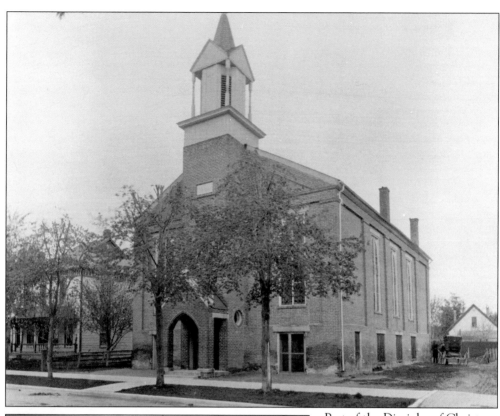

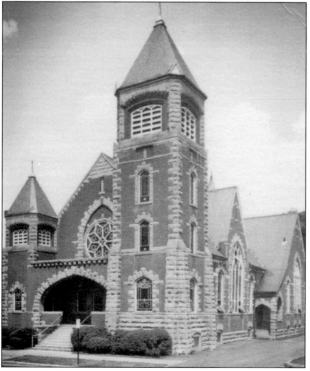

Part of the Disciples of Christ, the First Christian Church in Noblesville began in a log cabin on land donated by William Conner and his wife in 1829. In September 1835, Baptists merged with the Christian church, which was called The Church of Christ. In December 1854, fifty members withdrew and organized another congregation. They purchased a lot at the corner of Ninth Street and Maple Avenue and, in 1855, erected the church above, calling it The Christian Chapel. In 1897, the Christian Chapel was torn down to make way for a new building (left). When the church was dedicated on February 4, 1898, the name had been changed to First Christian Church. Joshua L. Fatout constructed the new Gothic-style church. (Both, First Christian Church.)

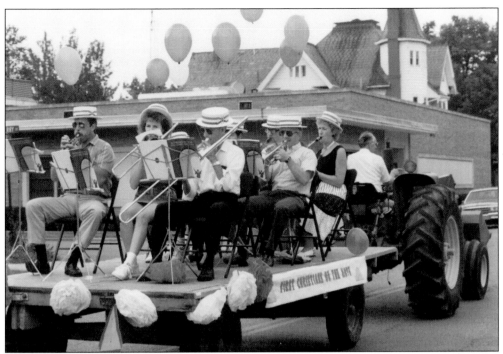

In 1985, feeling the need to expand, the First Christian Church congregation purchased land close to the intersection of State Roads 37 and 238. Ground breaking occurred in June 1988. The old building was sold to Raymond Adler in February 1989, and was remodeled as office space. On July 23, 1989, the congregation walked from the old church to the new one, celebrating the move. The photograph above shows the church band leading the parade, riding on a decorated flatbed. The 1990 aerial view below shows the new home of the First Christian Church on Herriman Boulevard. (Both, First Christian Church.)

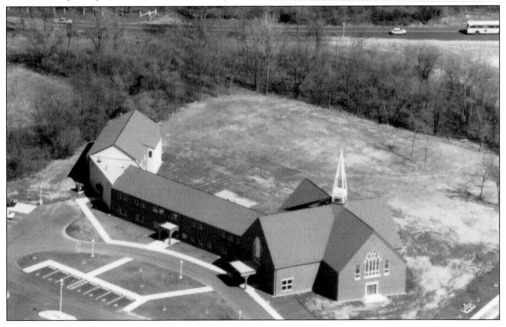

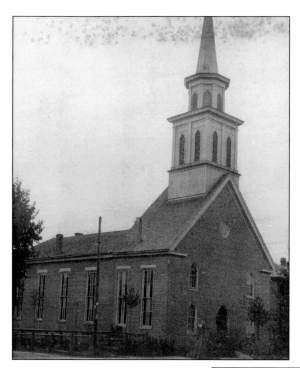

Old records indicate that the First Methodist Episcopal Church was part of the Fall Creek Circuit, which included Noblesville as early as 1828. Many of the early records of the Noblesville parish have been lost or destroyed. At the corner of Clinton and Anderson (now Tenth) Streets, a log cabin church, three brick church buildings, and a parsonage were all constructed on the same site in various years between 1836 and 1891. The photograph at left shows the second brick building, which was dedicated in 1853. (FUMC.)

Pictured here is the third brick building, erected in 1891 for the First Methodist Episcopal Church. For the laying of the cornerstone, the other churches in the city attended a cornerstone service on Sunday, October 25, 1891, at the courthouse. After the service, the attendees walked to the new building, where artifacts and the church history were placed in the cornerstone. The building was dedicated in 1893 and razed in 1964. (FUMC.)

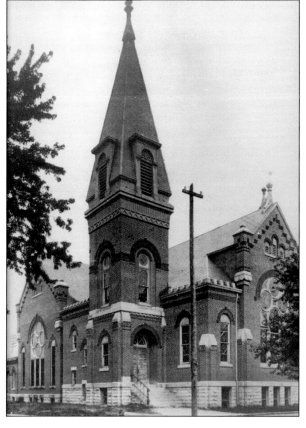

The Titan Society of the Methodist church, so named by Rev. H.J. Norris, was organized on April 11, 1898. The objectives of this group of women were social, charitable, and financial. From 1936 through 1940, this group completed many fundraising projects, paying church bills and buying furnishings for the church. This 1930 photograph shows members of the Titan Society in front of the church, at the corner of Clinton and Tenth Streets. (Paula Dunn.)

The Woman's Society of Christian Service (WSCS) was a reorganization of all the ladies' societies of the Methodist Church in 1940. In 1973, the WSCS became the United Methodist Women with 24 charter members. Their fundraisers supported mission outreach in the local and global communities. Here, members gather at the annual Rose Luncheon at the Forest Park Inn in 1968. (FUMC.)

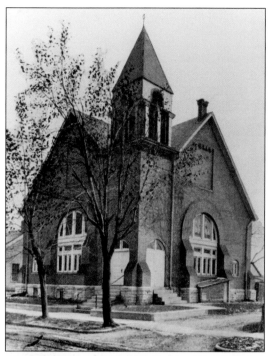

This 1900 photograph shows the First Friends Church, also known as the Noblesville Meeting House. Prior to the construction of this building (by Noah Earl), the Friends held services in various locations on the square. Other churches in the area cancelled Sunday services so all could attend the 1892 dedication. Between 1911 and 1914, the tower was removed from the building to prevent water damage from leaks. (First Friends Church.)

Without the faithful efforts of the Bene Facere Society (now known as the United Society of Friends Women or the Ladies Working Society), the finances of the First Friends Church would have suffered. This group was organized in 1891 by Jennie Brown and Anna Sanders, even before the church building was erected. Its purpose was to help with the financial, social, and spiritual life of the church. (First Friends Church.)

Four

IN THESE HALLOWED HALLS

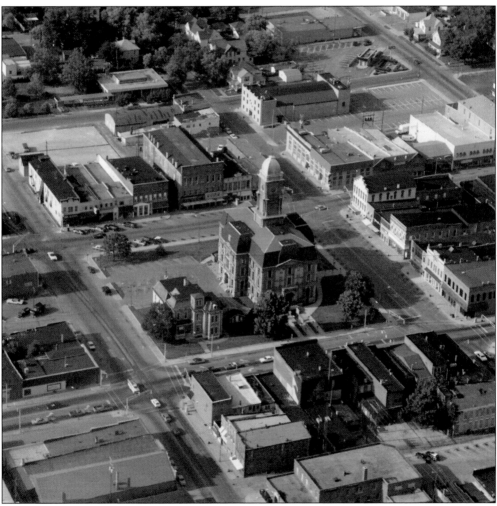

In this aerial view, the Hamilton County courthouse, sheriff's residence, and jail are the focal points of the business district. The layout, platted by William Conner and Josiah Polk in 1823, has endured through extensive growth as Noblesville transitioned from a small town to a city. Yet the landscape is ever changing. Green space now replaces the parking lot behind the sheriff's residence and a new judicial center sits on the west side of the square. (HCHS.)

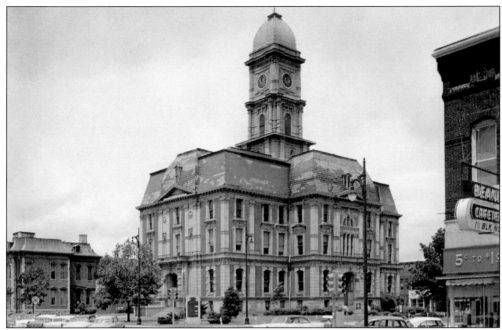

The passage of time is not always kind, even to architectural icons like the courthouse and sheriff's residence. Gone are the courthouse's mansard roofline, statues, and iron-ridge cresting. To its left, the prominent tower is missing from the sheriff's residence. Yet, the photographer captured this image either to document the loss or because these structures still held significant architectural value. Note that the traffic lights are not yet suspended above the intersection. (Carol Ann Schweikert.)

The names of the men pictured here, as well as their association to one another, have been lost to the passing of time. Also lost (perhaps more intentionally) are the outer courthouse doors behind them. These doors were part of the original construction but were removed early in its history. (Heylmann family.)

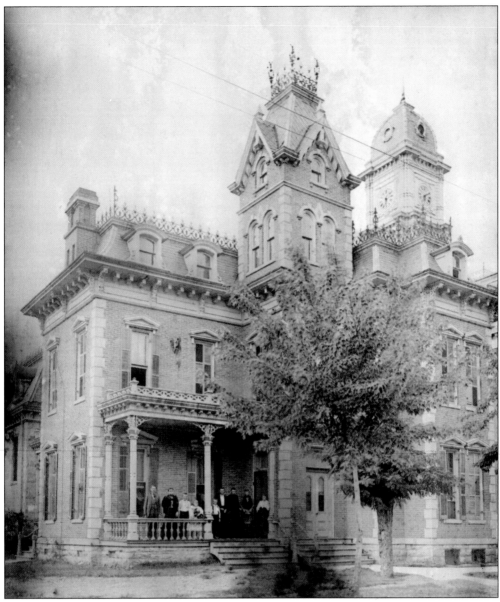

An iconic symbol, the Hamilton County Sheriff's Residence and Jail was constructed in 1875–1876 and was the county's third jail. This photograph shows Sheriff Franklin Thacker and his family on the porch. Thacker served as sheriff from 1894 to 1896. When a sheriff and his family resided here, his wife was often paid to cook and do laundry for the prisoners. The building was used as a jail and sheriff's offices until the 1970s. Unfortunately, it was not always a secure facility. When constructed, the cell locking mechanism was installed within the cell area and the windows were large enough for people outside to throw in tools to assist the prisoners with their escapes. In 1934, five prisoners, including a murder suspect named Willie Mason, escaped by sawing their way through the bars. This jail was one of several in Indiana in which Charles Manson spent time as a teenager. Among the jail's more infamous prisoners was D.C. Stephenson, grand dragon of the Indiana Ku Klux Klan, who was convicted of murder in the Hamilton County courthouse in 1925. (HCHS–Thacker-Fassett-Lucas Collection.)

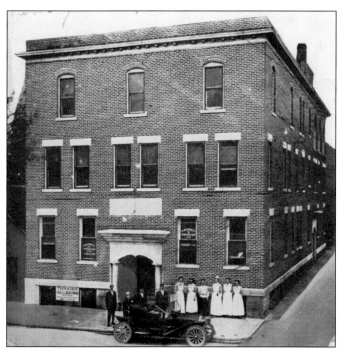

Drs. Madison and Samuel Harrell, brothers, built Hamilton County's first hospital, Harrell Hospital and Sanatorium, near the southeast corner of North Ninth and Clinton Streets in 1909. The three-story building with a basement had accommodations for 50 patients. It was equipped with the latest equipment, such as the Ozonator, which was used to convert oxygen into pure ozone, and the Therapeutic Leucodescent Lamp, which was used for the relief of pain. In 1914, the county bought the hospital and renamed it Hamilton County Hospital. (Gerry Hiatt from the Reed and Steve Miller Postcard Collection.)

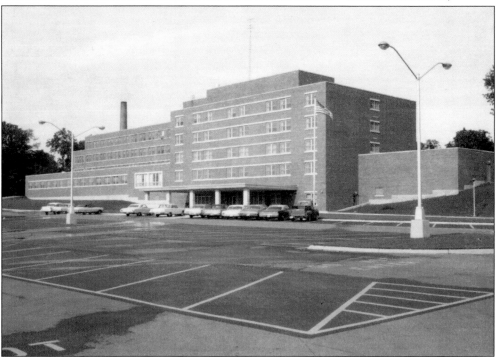

A new Hamilton County hospital, complete with all the latest facilities and equipment, was constructed in 1951 in the area known as Federal Hill. Appropriately, the new 86-bed hospital opened on National Hospital Day, May 12, 1951. The hospital was renamed Riverview Hospital in 1952. Since then, several expansions have taken place as the Noblesville community has grown. (Irv Heath.)

Mrs. Dr. Joyce F. (Richards) Hobson was likely the first female physician in Noblesville. (At that time, married female doctors were called "Mrs. Dr.") She graduated in 1878 from the Eclectic Medical College of Cincinnati. On May 22, 1879, the Indiana Eclectic Medical Association welcomed her as the "first lady member of the Indiana Association," introducing her as "a bright and intelligent little body." Hobson moved to Arkansas and later to Illinois, where she continued her practice until her death in 1929. (Dottie Young.)

Mivinda Malvina (Sample) Wheeler, better known as Mrs. Dr. Wheeler, was born in Hancock County, Indiana, in 1848. She graduated from the Indiana Eclectic Medical College (Beach Medical Institute) in Indianapolis in 1885. As an allopath, she located her practice in Noblesville as the protégé of Mrs. Dr. Joyce Hobson. Following her 23-year career, she died in Noblesville in 1922. (Dottie Young.)

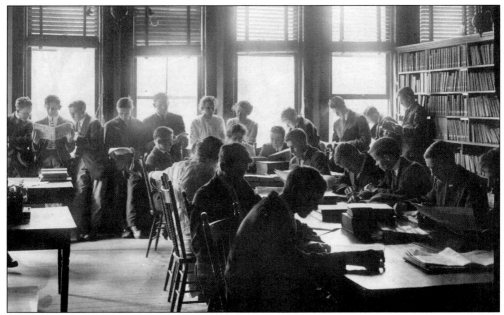

The Hamilton East Public Library began in 1856 as the Hamilton County Mechanics Library Association. Throughout the years, the library changed locations as often as it changed names. In 1900, the public library moved to a room at the new Conner Street high school called the Reading Room. The school board took charge of the library until it transferred ownership to the newly created Library Board of Trustees in 1911. (HEPL.)

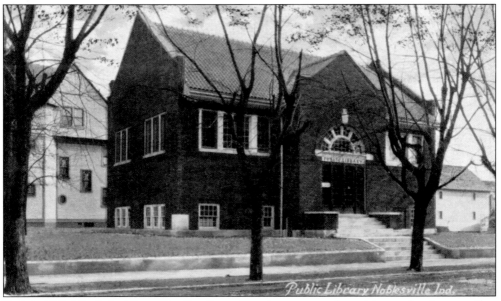

Early in 1911, Miss Lulu Miesse, Reading Room librarian, presented a petition to the city council to appropriate funds for the purchase of a suitable location for a library. In those years, philanthropist Andrew Carnegie donated funds to many communities for the construction of what became known as Carnegie libraries. In June 1911, the city purchased the lot on the southeast corner of Tenth and Conner Streets. Shown here is the Carnegie library, which was completed in 1913, establishing the Noblesville Public Library. (HEPL.)

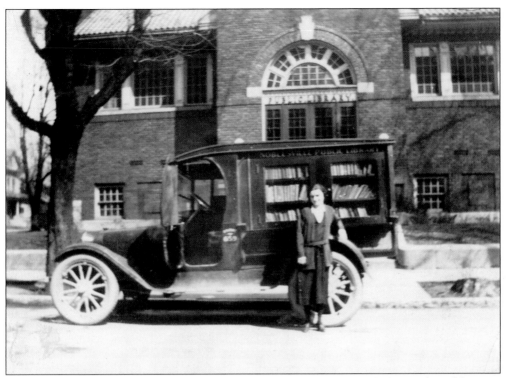

In 1920, Lulu Miesse renovated a Dodge Brothers commercial car, which she purchased from W. Hare & Sons. The mobile library began making trips into the surrounding area. She named the truck Parnassus, from a novel called *Parnassus on Wheels* by Christopher Morley, which told the story of an itinerant book salesman. In May 1932, Parnassus stopped making book runs, and in October, the "book auto" was sold to a local farmer. (HEPL.)

Audrey Haworth—who served the library for over 50 years, including as library director from 1945 to 1973—stands in front of the entrance to the Indiana Room in the Carnegie building. After her retirement as director in 1973, she served as the Indiana Room curator. The Hamilton County Historical Society worked with the library to assemble the Indiana Room collection of local history and genealogy. (HEPL.)

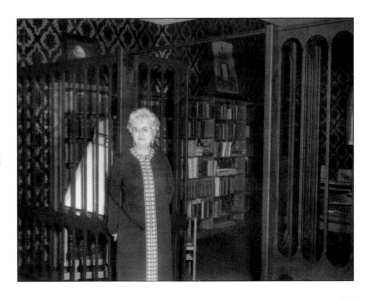

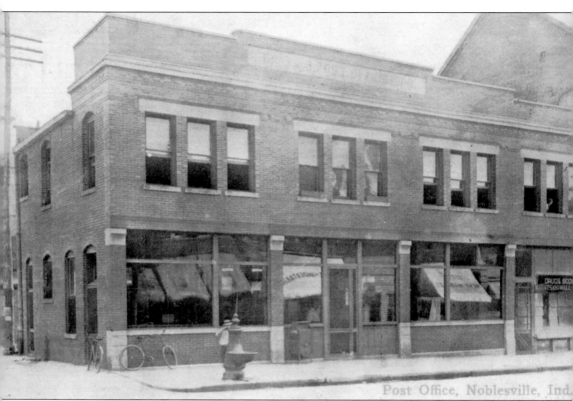

Post Office, Noblesville, Ind.

A federal post office was established in Noblesville on March 10, 1824. Free delivery started in the city in 1902. Until a permanent location was constructed, the post office was housed in various rented spaces, usually in commercial storefronts around the public square. This image shows Noblesville's first permanent post office, constructed in 1906 (when first-class letters cost just 2¢ to mail). At the time, mail was delivered three times a day in the business district and twice daily to residences. Although constructed specifically for the post office, it was built by J. Joseph and Company and leased by the government. The post office remained at this Logan Street location until 1932. Note the water fountain on the sidewalk in front of the building. (Gerry Hiatt from the Reed and Steve Miller Postcard Collection.)

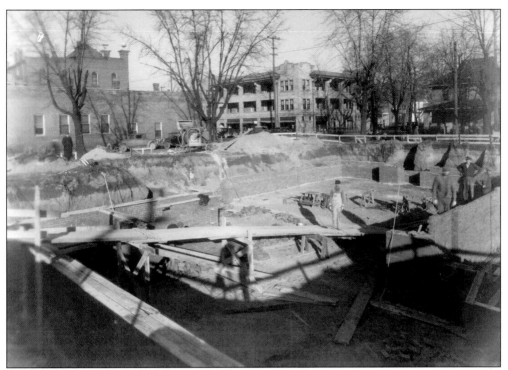

This image was taken in December 1931, as the LaSalle Construction Company oversaw construction of the foundation for the new US post office at South Ninth Street and Maple Avenue. Although the site had been selected in 1915, World War I delayed construction. Noah Earl, a local contractor, was the brick mason. Also visible in this photograph are the Richwine Apartments in the background and the south elevation of the Wild Opera House on the left. (Steve Schwartz.)

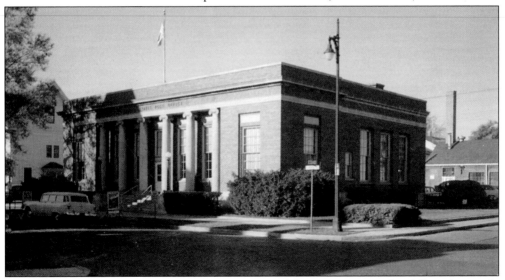

The cornerstone was laid on January 22, 1932, in an elaborate ceremony that followed a parade through the city and was attended by veterans from the Civil War through World War I. During the building's use as a post office, 1932–1989, the cost to mail a first-class letter rose from 3¢ to 25¢. (Gerry Hiatt from the Reed and Steve Miller Postcard Collection.)

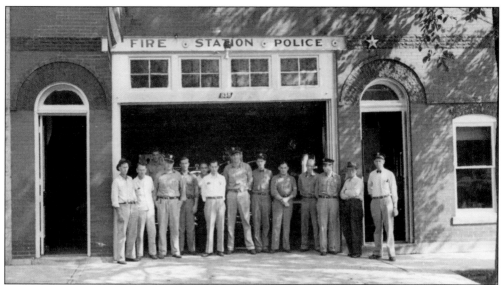

"After so long, a great want is supplied," announced the *Hamilton County Register* in 1870. Noblesville's first city hall was located on the third story at Logan and North Ninth Streets. The second, seen here, was on Maple Avenue and often appeared in the backdrop of photographs of the police and fire departments. The horse stables inside were removed in 1915 to make room for the city's first motorized fire truck. (Noblesville Fire Department.)

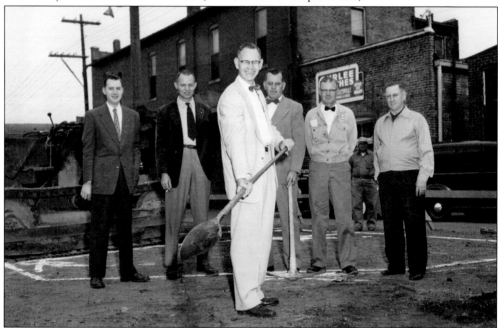

After Indiana's state fire marshal condemned Noblesville's city hall, the council approved a resolution in 1953 calling the Maple Avenue location "inadequate, unfit, and dangerous." They hired A.A. "Gus" Faulstich to prepare plans for a new city building on South Eighth Street. At the ground breaking on April 29, 1954, standing from left to right, are John Neal, Glen Fearheiley, Mayor Herman Lawson (with shovel), John Williams, Harold Crist, and Archie Hutchens. (Mary Sue Rowland.)

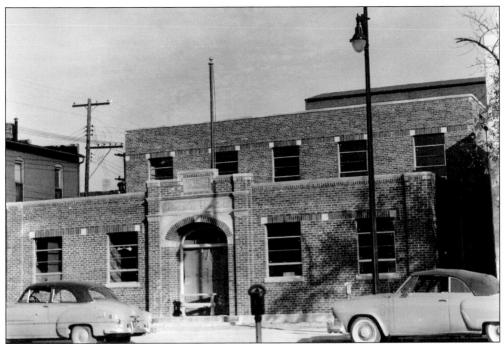

The new Noblesville City Hall officially launched with an open house on March 29, 1955. Although city government had grown, the new structure remained all-inclusive, containing the offices of the mayor, clerk-treasurer, and chief of police, as well as two jail cells, a police laboratory, and a parking meter–repair room. The second floor housed the auditorium for city court and council meetings as well as the offices of the city judge and street commissioner. (Mary Sue Rowland.)

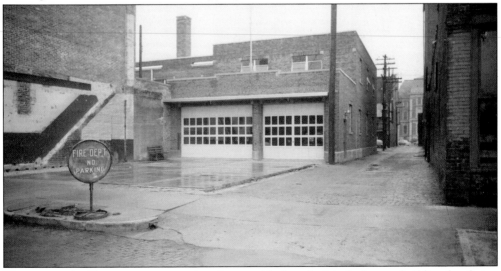

The new city building was constructed in the same block as the Maple Avenue building, but facing Eighth Street. The fire department, seen here, was located in the rear of the new facility, facing Maple Avenue. The building included sleeping quarters, a kitchen, recreational facilities, and lockers for the firemen. The previous city hall, which sat in front of this garage, was demolished in 1954 as the new building was completed. This remained the only fire station for the city until the late 1970s. (Noblesville Fire Department.)

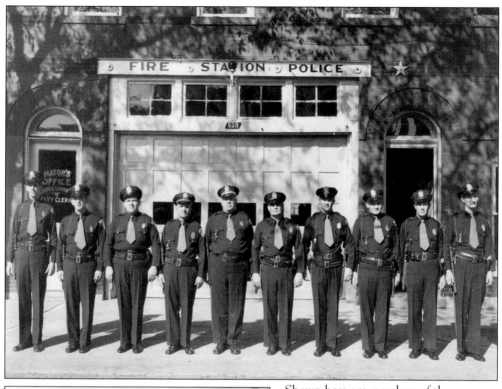

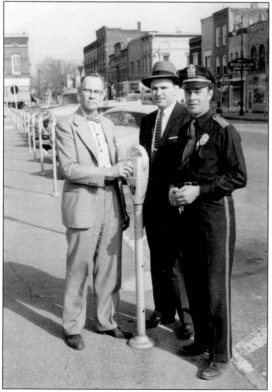

Shown here are members of the Noblesville Police Department in October 1948. Pictured are, from left to right, Benny Archibald, Bill Elder, Sid Elder, Otto Kirby, Harley Shoaf, Raymond Camp, Larry Boyd, Gene Noble, Joe Love, and John Woodward. Joe Love worked for the police department from 1947 until his retirement in 1967. He served as chief of police twice, from June 23, 1948, to March 8, 1954, and again from January 1, 1964, to August 1, 1967. (Joan Love.)

Parking meters were first installed in downtown Noblesville in July 1948, on the four sides of the public square. The goal was not to raise revenue, but to control parking with a more frequent turnover of parking spaces. Officer Joe Love was responsible for keeping the meters in good repair and collecting the revenues. Pictured are, from left to right, Herman Lawson (mayor), Paul Green (meter salesman), and Joe Love. (Joan Love.)

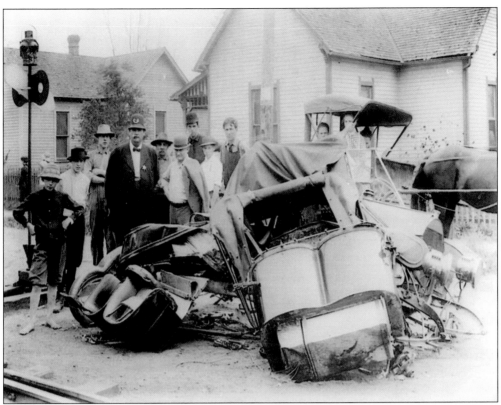

The Noblesville Police Department has, during its many years of service to the community, responded to numerous accidents and calls for assistance from its citizens. Vehicular accidents are just one of the emergencies to which they respond. These dramatic photographs document two accidents that occurred in the city. The incident shown above happened on South Eighth Street in 1910, when a train apparently struck a visiting doctor's Hudson automobile. The officer in the photograph is thought to be Russ Eador. In the 1973 image at right, an automobile failed to stop (for unknown reasons) before ending up on the steps of the post office on South Ninth Street. The officer seen here is believed to be James Ebert. (Both, Noblesville Police Department.)

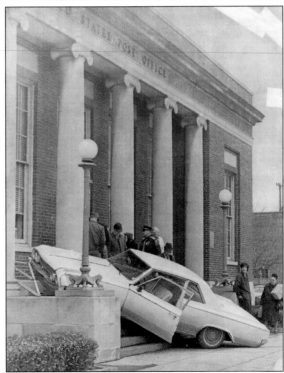

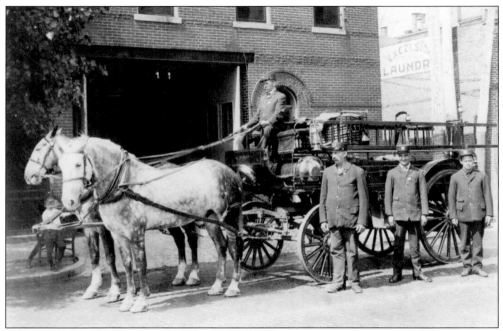

The Noblesville Hook and Ladder Company was organized on February 20, 1871, "for protection from fire this town has as yet had." From this all-volunteer organization came the Noblesville Fire Department, which was organized on September 25, 1901, with Chief Elwood Wilson and two firemen. After serving less than a year, Wilson was replaced by James B. Garrison. The photograph above, taken in the early 1900s, shows the fire wagon in front of the city building on Maple Avenue, which, in addition to the fire department, also housed the mayor's office and the police department. The photograph below captures, from left to right, Fire Chief James B. Garrison, unidentified, Samuel L. Quear, and Frank Stroup. A team of fine, strong horses pulled the fire wagon until it was replaced with the purchase of an "automobile truck" in 1915. One horse, Jack, had served the department since its inception. In addition to the horse-drawn combination hose and chemical wagon, the department owned two hand-hose carts. (Above, Noblesville Fire Department; below, HCHS.)

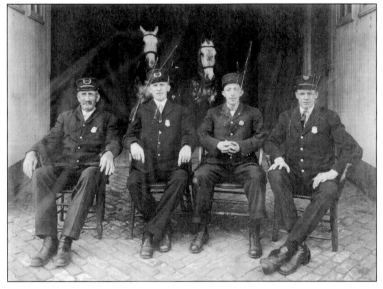

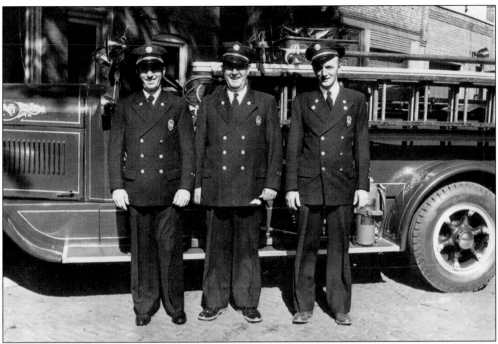

These images show the changes that occurred in the Noblesville Fire Department between the 1930s and the 1950s. The image above captures the department's three firemen with the 1935 fire engine in front of the Maple Avenue city building. From the department's inception in 1901 through the early 1930s, one chief and two or three paid firemen were employed. As the image below shows, over the next 20 years, the staff grew to 10, including both a fire chief and an assistant chief. Along with the other city offices and services, they relocated from Maple Avenue into a new, larger facility on South Eighth Street in 1954. Although not pictured, the fire department also replaced the aging 1935 engine with a new fire truck in 1957. (Both, Noblesville Fire Department.)

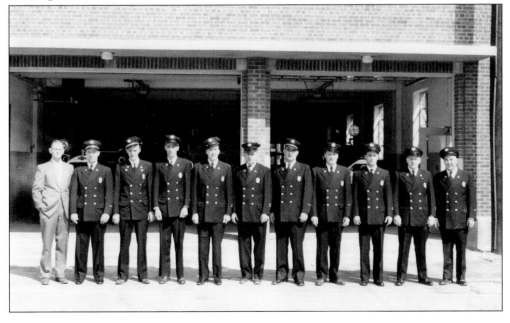

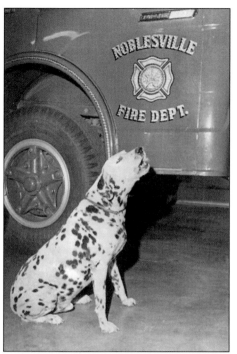

For 25 years, the fire department owned a succession of Dalmatian dogs, all named Sparky. The third and final dog was born in 1976 near Strawtown and was quick to respond to the fire alarm. Senior Fireman Tom Jesse often said, "You couldn't throw that dog off the truck." This Sparky was retired after about five years at the department because he repeatedly violated the leash law, running loose in Noblesville. Banished to a farm near Arcadia, Sparky died September 20, 1989. (Noblesville Fire Department.)

Fire safety and education have long been part of the fire department's mission. In addition to fire-safety demonstrations at school buildings, fire drills were conducted on a regular basis. In 1914, a new Indiana law required monthly fire drills in public schools. It was suggested boys precede girls out of the building to avoid trampling and to prevent the girls from being frightened. This tubular fire escape slide was installed at Second Ward in 1942 for just $883. (Noblesville Fire Department.)

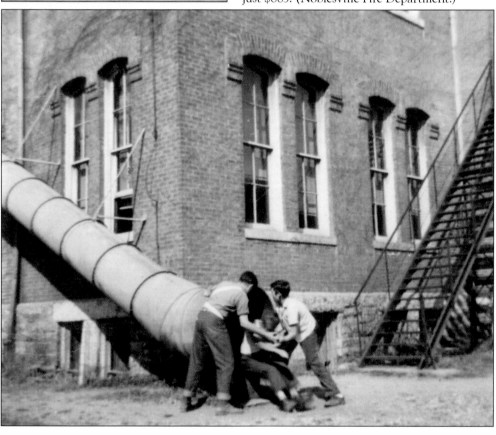

Five

WORKING ALL DAY LONG

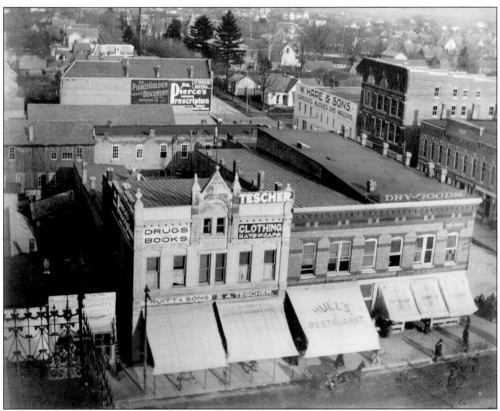

This view from atop the courthouse shows the Tescher clothing store, which later was sold to John R. Sperry and renamed Sperry Clothier. Samuel A. Tescher was a dealer in clothing and gents' furnishing goods and was a member of the Commercial Club. The store occupied space in a building erected by Leonard Wild in 1880. Wild, with his son Frank, also owned a dry-goods store at the site. Sharing the floor space was the business of Truitt and Sons, which sold drugs and books. In 1903, Wild sold the building to John G., Frederick E., and George B. Heylmann. In the background of the photograph is the W. Hare and Sons carriage and buggy business, which was demolished by Wainwright Bank and Trust to make way for an addition and parking lot. Notice the advertisements painted on the sides of some of the buildings. A small white house sits on the current site of city hall. (Irv Heath.)

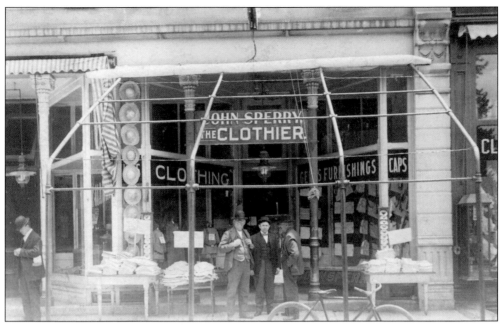

In 1907, John R. Sperry (center) opened Sperry Clothier. He bought the store, where he had once worked as an employee, from Samuel Tescher. This was his second store, his first being located in Lapel. In the last 25 years of his life until his death in 1958, Sperry worked for a custom tailoring shop. (HCHS–Sperry Collection.)

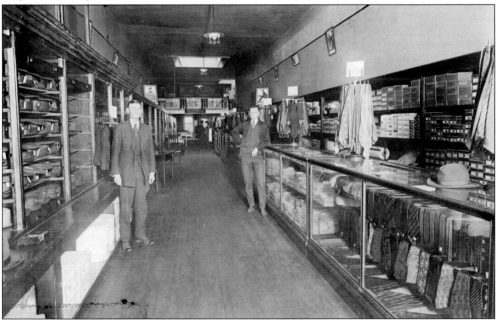

This early 1920s image shows the interior of Sperry's Noblesville store. William "Bill" Cloe (left) was a fixture in the store for many years. While still in high school, Chester Casler (right) came to work for John Sperry. An ambitious and industrious employee, Casler later worked with H.P. Wasson in Indianapolis. Note the men's hats on the left side and the ties on the right. (HCHS–Sperry Collection.)

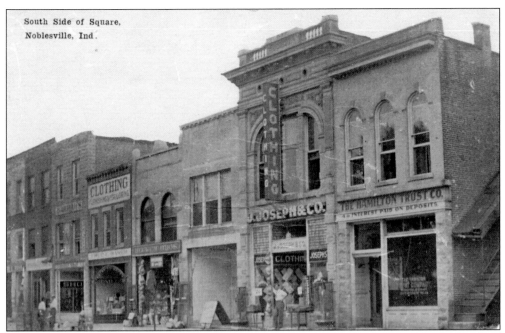

This 1912 postcard shows the Hamilton Trust Company, which was located on the south side of the square. Hamilton Trust Company was incorporated March 20, 1905, with George Bowen as president. On January 23, 1915, it was forced to close by the state auditor on the basis of "wildcat speculation, kiting of checks, and disregarding of banking laws." Its closure set into motion the closure of four other banks in Hamilton County. (Gerry Hiatt from the Reed and Steve Miller Postcard Collection.)

The first bank in Noblesville was the Citizens' State Bank. When it opened its doors on January 25, 1871, it was a private business organized under the name Citizens' Bank by William M. Locke and George H. Bonebrake. In September 1877, it reorganized, becoming a state bank and changing its name. William E. Dunn became president of the bank. (Gerry Hiatt from the Reed and Steve Miller Postcard Collection.)

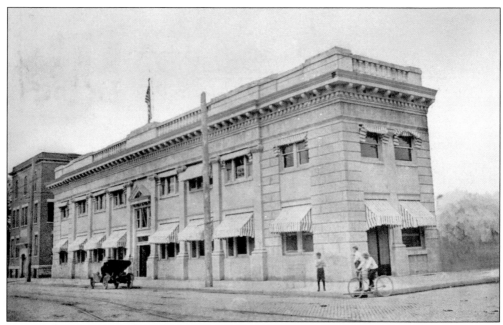

In 1883, the First National Bank opened for business with Marion Aldred as president. In 1909, the bank constructed this building on the northeast corner of Ninth and Logan Streets. Constructed by John Durflinger, it was said to be "one of the finest bank buildings in this portion of Indiana," having safe deposit boxes and the strongest vaults in the county. It closed in 1926. Two years later, American National Bank purchased the building. (HCHS–Roberts Collection.)

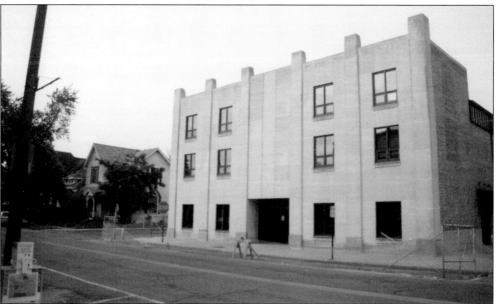

This 1980 photograph shows the renovated Diana Theater building, which served as American National Bank's loan center and main offices. The loan department was on the first floor of the building, while the credit and bookkeeping departments occupied the second floor. The boardroom was on the third floor. This structure was demolished in 1993 by Society Bank, which had bought American National. (Dottie Young.)

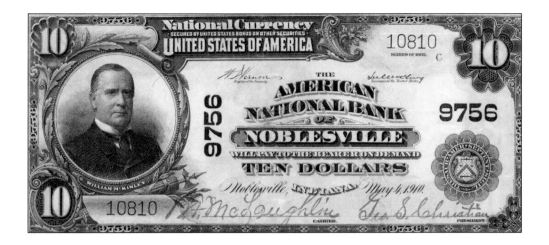

From 1863 to 1935, national banknotes, sometimes called "hometown notes," were issued by national banks. Banks would deposit bonds in the United States Treasury, which would back the privately issued banknotes. The banknotes were validated with the signatures of two bank officers, usually the cashier and the president. During the Great Depression these national banknotes were retired as a currency type, and privately issued banknotes were eliminated. Above is the 1902 blue seal series, which was printed until 1929. Below is the 1929 series banknote, the first of the small-size notes. The series date reflects the year the note was designed, not the date it was printed. Cashier Benjamin F. McLaughlin signed both notes, but under different bank presidents, George S. Christian and John C. Craig. All were bank officers at American National Bank. (Above, anonymous donation; below, Stephen Craig.)

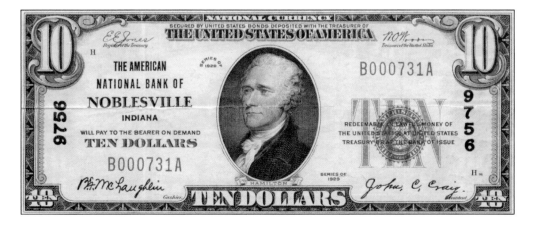

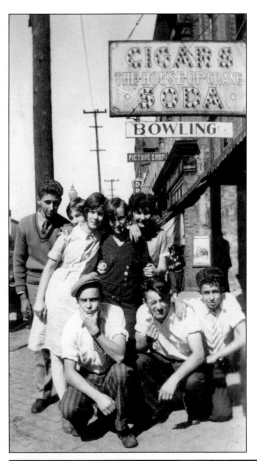

In 1894, Harvey Crane and his son Elmer opened a cigar store, called H. Crane & Son, on the south side of the square. The retail and wholesale business prospered as sales expanded throughout Indiana. Following his father's death, Elmer changed the name to The House of Crane. After relocating to the east side of the square, The House of Crane expanded with a billiard hall, bowling alley, and confectionery. It was a popular spot for high school students. (Dottie Young.)

5¢ to $1.00 Haffner Stores was on the northeast corner of Ninth and Conner Streets, across from the courthouse. It was the typical variety store, selling inexpensive items and keeping candy jars full of treats for children. It was open for business from the late 1940s through the mid-1960s. The Hamilton County Red Cross was above Haffner, and next door was the Kroger grocery store. (Carol Ann Schweikert.)

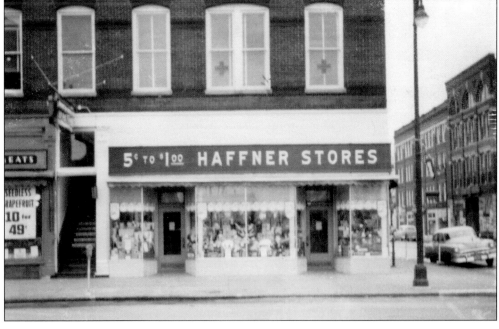

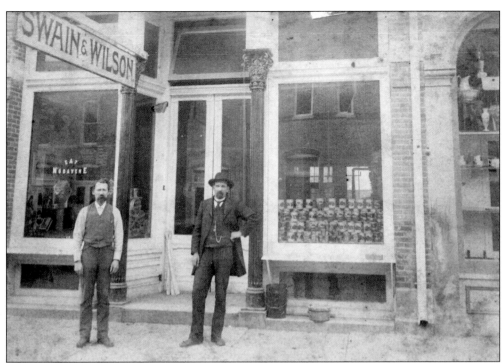

William Nathan Franklin Swain (left) and his cousin Elwood Wilson (right) partnered to operate a dry-goods store in the Caylor Block in the 1890s. When the partnership dissolved, Swain operated the Cottage Grocery on South Tenth Street before moving to California, where he died in 1926. Wilson worked as watchman for the Nickel Plate Railroad and was killed by a southbound freight train on the southwest corner of the square in 1930. (Margaret Musgrove.)

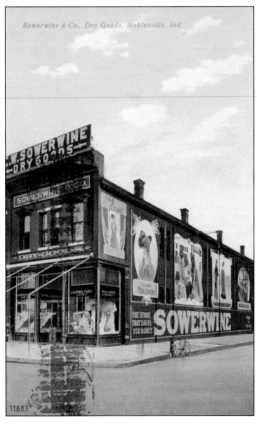

The C.W. Sowerwine Dry Goods store was located on the northwest corner of Logan and North Ninth Streets. Advertising on building facades, as employed here by Charles W. Sowerwine, was a common practice. He operated dry-good stores as a sole proprietor, as well as in partnerships with both William H. Craig and Eugene Osbon. In the late 1910s, Sowerwine moved to Huntington, Indiana, where he opened another dry-goods store. (Steve Schwarz.)

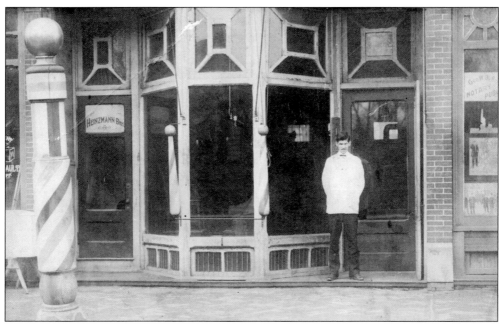

A young George E. West set up his barbershop at 23 North Eighth Street on the west side of the square in 1908. West and his fellow barbers, Edgar Mosbaugh and Floyd Voss, usually cut hair for 20¢ and gave shaves for 10¢ on Saturdays when farmers from miles around came to town. As customers waited for their turn, conversation would often turn to their wartime experiences, with the men exchanging stories from the Spanish American War and both World Wars. The Lake Erie & Western Railroad rattled past every day loaded with passengers and freight. As time passed, the hot-towel steamers and the shaving mugs disappeared. The mirror in the shop remained a constant from the very beginning until West's retirement. (Both, Kurt Meyer.)

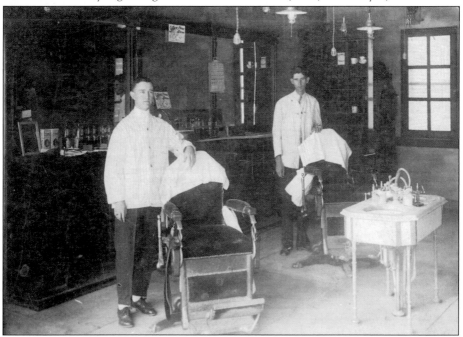

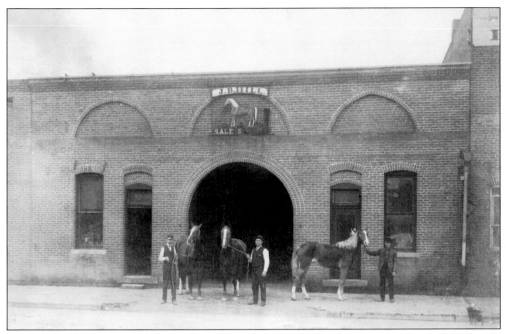

Pictured here is the J.D. Hill Livery Stable, which was owned and operated by Jacob D. Hill at 61 Conner Street (now 610 Conner). Hill was active in the livery business from 1894 to about 1918. When he thought he could see the end of the horse-and-buggy days due to the emergence of the automobile, he disposed of his interest in the livery business. (Paula Dunn.)

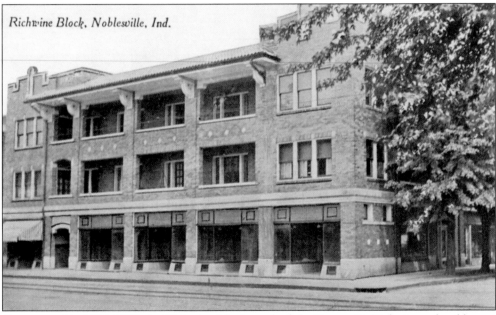

Constructed in 1914–1915, the Richwine Block was built by George C. Richwine, a local buggy, carriage, and wagon manufacturer. His home and business were originally located on this property at North Ninth and Maple Avenue, but he demolished both to construct this Mission-style building. The apartments on the second and third floors were fitted with fold-out beds, built-in china cupboards, and a copper-tube speaker system. (HCHS–Roberts Collection.)

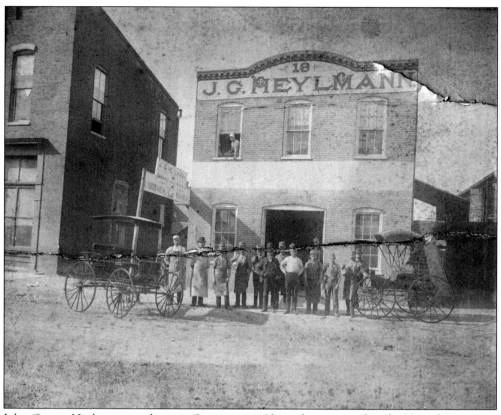

John George Heylmann was born in Germany in 1834 and immigrated to the United States as a young man. After learning the buggy- and wagon-making trade in Ohio, he settled in Noblesville in 1855. He partnered with Wesley Hare for about 15 years, until the two "had a difficulty" and dissolved their partnership in 1877. Built in 1876, the building shown above was located at what today is 948 Conner Street. (Heylmann family.)

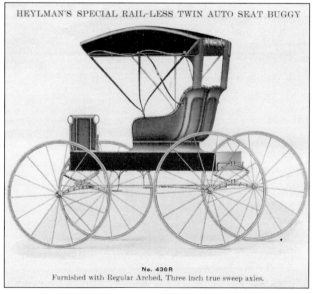

HEYLMAN'S SPECIAL RAIL-LESS TWIN AUTO SEAT BUGGY

No. 436R
Furnished with Regular Arched, Three inch true sweep axles.

The firm J.G. Heylmann & Sons was in operation in Noblesville for more than 50 years. The firm often used brochures like this one to describe its products and options. The company also offered repairing and repainting services. In later years, it discontinued wagons and focused its efforts on "lighter vehicles." By the early 1910s, the business had expanded to automobiles, with the Maxwell and Hupmobile in their showroom. In 1913, the firm was one of seven local businesses to participate in Noblesville's first Automobile Show. (Heylmann family.)

In 1899, J.G. Heylmann & Sons improved its facilities with the structure pictured at right, which reflects the Chicago style of architecture. The new repository at 954 Conner Street was constructed next to the original facility at 948 Conner Street. The structure included three floors, with a showroom on the first floor and manufacturing facilities above. Large ramps between floors made it easy to move the vehicles from floor to floor. (Heylmann family.)

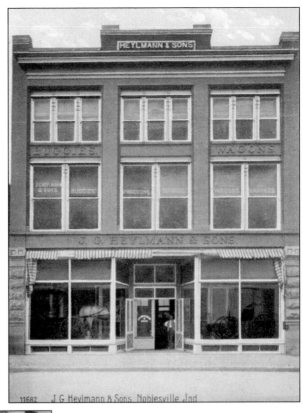

Pictured here is Frederick E. Heylmann in the alley behind the Conner Street manufacturing facility. He was one of six children born to John G. and Susan (Barth) Heylmann. He joined the family business in 1883 and his brother George joined in 1894. After George's death in 1916, Frederick became the sole owner. In the 1910s, he retired and closed the company. The building housed various tenants and remained in the family until 1927. (Heylmann family.)

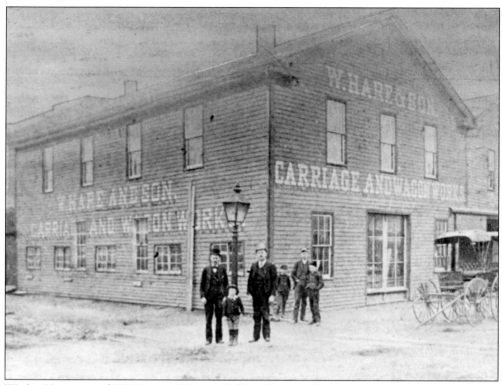

Wesley Hare opened W. Hare and Son in Noblesville in 1847. According to family records, the frame building seen in this 1880s photograph stood on the corner of Conner and Tenth Streets. Standing in the foreground from left to right are unidentified, Frank Hare (young boy), and Elbert M. Hare, oldest son of Wesley. In the 1910s, the Hares constructed a brick four-story manufacturing facility on the southwest corner of Conner and Tenth Streets. (Hare family.)

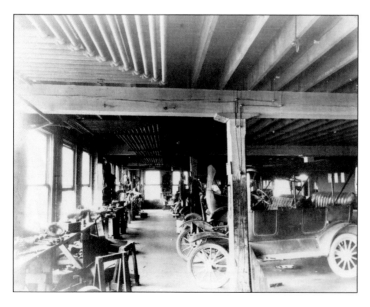

This photograph shows the interior of W. Hare and Son's manufacturing facility. With the development and growth in popularity of automobiles, manufacturers of buggies, carriages, and wagons either adapted or went out of business. According to the family, not everyone was convinced that automobiles would replace horses. For several years, both carriages and automobiles were sold in the Hare showroom. (Hare family.)

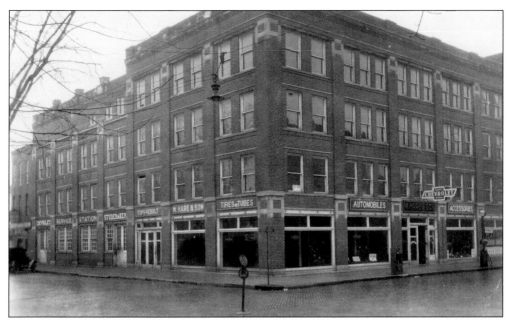

The signage on Hare's 1910s manufacturing facility depicts the company's transformation from buggies and carriages to automobiles and accessories. Seemingly, W. Hare and Son adopted automobiles more slowly than its competitors and did not participate in the 1913 Automobile Show in Noblesville. After trying several different makes of automobiles, the company signed an exclusive agreement with Chevrolet in 1923. Note the street lamp hanging in the center of the photograph and the traffic signal in the middle of the intersection. (Hare family.)

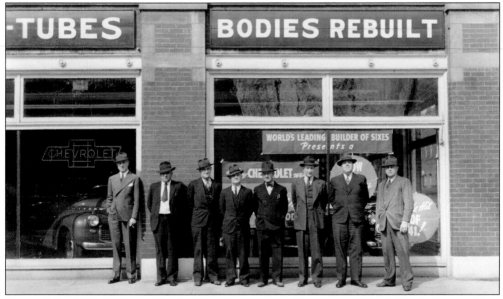

Pictured April 11, 1941, outside the Hare showroom at Conner and North Tenth Streets, from left to right, are Willard J. Hare, J.R. Cook, Frank "Hank" Reed, Charles W. Sylvester, Homer Wall, A.F. "Red" Whelchel, John Carroll, and Frank Hare. In the early 1930s, Willard purchased his brothers' holdings and became the sole owner. During World War II, the company had only two employees and no new cars to sell for three and a half years. (Hare family.)

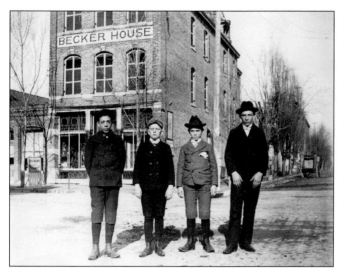

These four young men pose for a photograph near North Tenth and Conner Streets around 1890. Constructed around 1886, the Becker House was owned by Julia Becker, whose husband operated the confectionery, steam bakery, restaurant, and boardinghouse. The restaurant advertised "meals at all hours and oysters in season in every style." Later, John Dietrich operated the Grand Hotel at the site, with fireplaces in every room. Thomas T. Butler opened his printing business here in the early 1910s. (Irv Heath.)

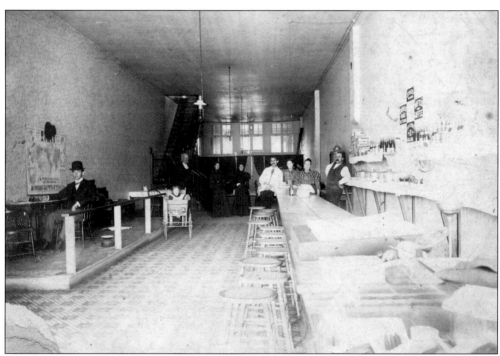

This early-1900s photograph shows the interior of the Hawkins Hotel and Restaurant, where confectionaries were also sold. George Hawkins owned and managed the hotel, located on the north side of the square, until he retired in 1909. After retiring, he continued to make and sell candy, taffy, and popcorn balls, which became the start of Gran'pa's Popcorn and Candy Store. (Jane Cullen Gawthrop.)

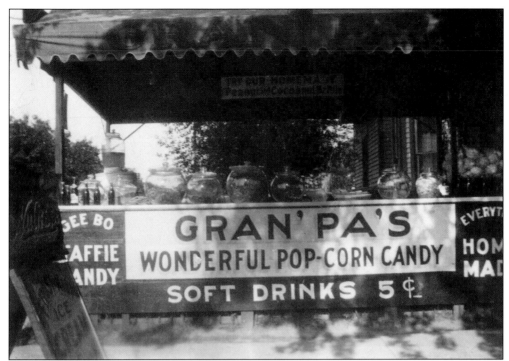

In 1869, George and Margaret Hawkins set up stands at county fairs to sell taffy, caramel corn, and popcorn balls. They also sold their confections in the Hawkins Hotel, which they owned. In 1898, William Mabee, their son-in-law, stopped cutting hair and started making popcorn and candy. The photograph above shows the 1902 open-air stand in front of the Mabee house. Starting in 1923, William and his wife, Fairy, sold caramel corn to motorists on the newly opened State Road 37, which ran in front of their house on Tenth Street. They soon constructed a more permanent building on the corner of Harrison and Tenth Streets. Although the store closed in 1976, the building still stands. The 1950s photograph below shows the inside of Gran'pa's Popcorn and Candy Store. The cash register is the same one used in Hawkins Hotel and Restaurant some 70 years earlier. (Both, Jane Cullen Gawthrop.)

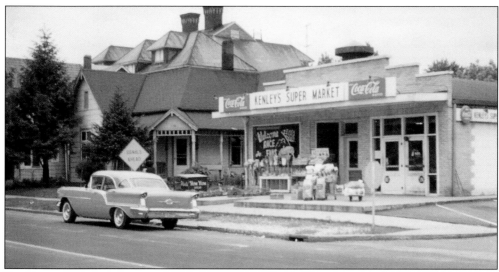

For 58 years, Kenley's Supermarket was an integral part of the Noblesville business community. The supermarket opened in 1940 on the downtown square. In 1952, the Kenleys purchased this property on South Tenth Street and, according to the family, became the first business to leave the downtown area. Advertisements touted the benefits of the new store as one-stop shopping with plenty of free parking, an expanded self-service meat department, and a remarkable four feet of health and beauty aids. (Nancy Kenley.)

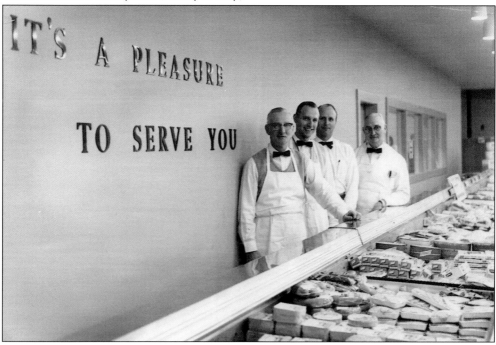

Founded by Howard A. Kenley Sr. and operating from 1940 until 1998, Kenley's Supermarket was a family business. When the store opened, five of its six employees were Kenleys. This photograph taken in the meat department captures two generations. To the far right stands founder Howard A. Kenley Sr. With him are, from left to right, Robert J. Kenley (Howard Sr.'s brother), Jack Kenley (Howard Sr.'s son), and Howard Kenley Jr. (Howard Sr.'s son) (Nancy Kenley.)

Established in 1871, The City Mills was a grain mill on the northwest corner of Conner and Sixth Streets. In 1901, Grant Caca (pronounced "kay-kee") partnered with his father-in-law, Finley Smock, under the name Smock and Caca. That same year, the original mill burned and was rebuilt. The mill remained operational in the Caca family until 1975, when it was razed for a parking lot. Here, reserve officer Chester Bentley is directing traffic. (Terry Bentley.)

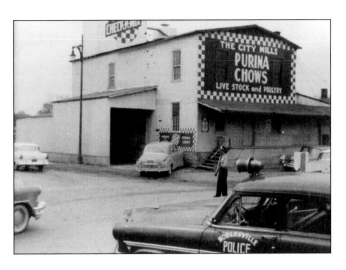

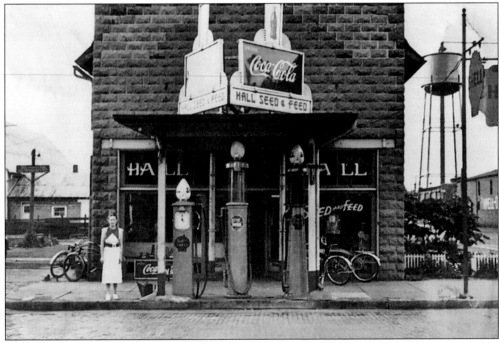

This July 4, 1939, image shows the Hall Seed and Feed service station at the northwest corner of Logan and Eighth Streets. Harry Hall owned and operated this service station selling coal, feed, seed, and gasoline for 15 years. After the business closed, Hall entered the plumbing trade. Standing in front is his daughter Neva Hall Barr, mother of Judge Jerry Barr. (Ruth Hall Lusher.)

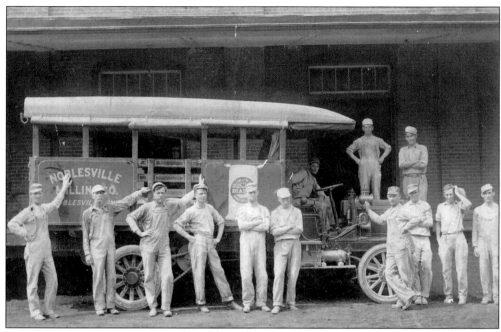

Daniel W. Marmon opened the Noblesville Milling Company as a "model mill" in 1890. Marmon was president of Nordyke and Marmon, an Indianapolis company that manufactured milling equipment. The Noblesville facility was intended to test new designs and demonstrate machinery to customers from around the world. This early 1900s photograph shows a group of employees by a delivery truck outside the mill. (HCHS.)

This 1903 image shows mill employees as Nordyke and Marmon finished its last major mill expansion. The stenographer in the office window at left is Robert Graham. The men outside are, from left to right, (first row) John Bowlen (packer), Walter Sohl (corn miller), Arley Hutchens (packer), William Armstrong (sweeper), and Lewis Rayl (first engineer); (second row) Aaron Mendenhall (elevator); Fred Atkins (weighman), Fred Kieser (packer), Charles Smith (oiler), Frank Madge (miller), Leonard Eubank (stevedore), and Edward Haines (exchange). (HCHS.)

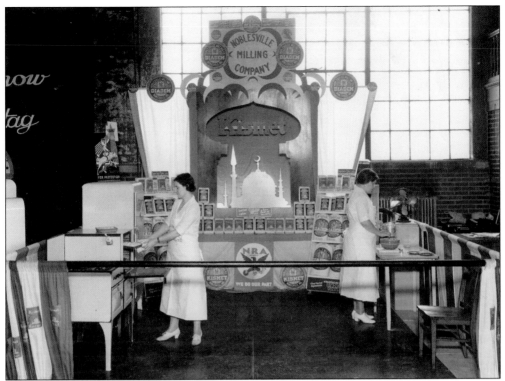

These ladies, pictured in a test or demonstration kitchen in the mid-1930s, were baking with mill products, including Diadem flour and Kismet cake flour. By 1903, the company had added a corn mill, a bran room, and the water tower. The blue eagle poster from the National Recovery Administration (NRA) marks the mill as a member. Formed in 1933 and dissolved January 1, 1936, the NRA's goal was to create codes of fair wages and pricing for each industry. (HCHS.)

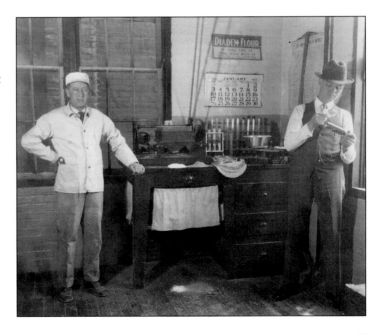

This January 1926 photograph shows mill employees in what might have been a test area, as small amounts of grain and flour are visible on the worktable. In 1926, having expanded their interests beyond milling, the Marmons sold Nordyke and Marmon to focus on automobiles. Since the model mill was such a successful venture apart from manufacturing, the Marmons retained ownership until 1941. (HCHS.)

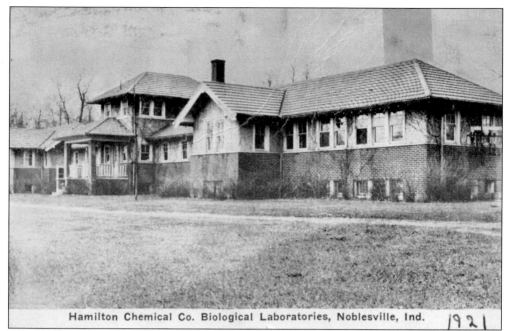

Hamilton Chemical Co. Biological Laboratories, Noblesville, Ind. 1921

This 1921 postcard shows the Hamilton Chemical Company laboratory and office that developed and produced serum to combat hog cholera. In its advertisements for the serum, the company boasted that it had "not been equaled by any other brand." When the company closed in 1928, George Ball bought the property and donated it to the Forest Park board. The main building was used as the bathhouse for the 1931 swimming pool. (Gerry Hiatt from the Steve and Reed Miller Postcard Collection.)

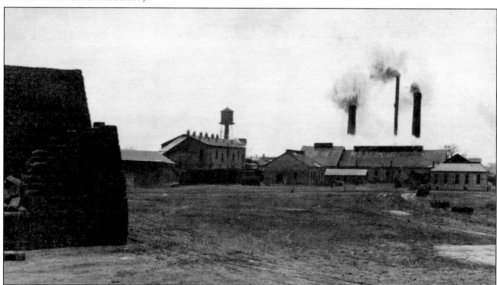

American Strawboard Company was founded in 1889 on the southwest side of Noblesville, between Chestnut Street and the White River. It bought straw from local farmers to make corrugated cardboard. In 1923, the Ball Brothers Company of Muncie, Indiana, bought controlling interest in the plant and manufactured cardboard boxes for its canning jars. In June 1954, the plant was sold to the Container Corporation of America. (HCHS–Roberts Collection.)

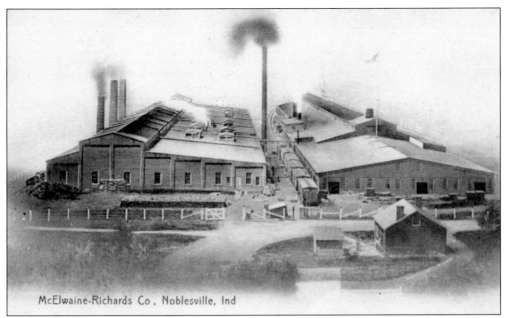

McElwaine-Richards Co, Noblesville, Ind

In the late 1800s, the Noblesville Foundry Machine Company began operation at the corner of Division and Wild (now South Seventh) Streets. The plant operated a foundry and machine shop, which continued under the name McElwaine Richards Co. Machine Works. Under this name, the company relocated farther south on Eighth Street. Around 1910, the business changed hands again and became known as the Union Sanitary Manufacturing Company. The company manufactured enamelware, including bathtubs and lavatories, and employed around 300 people. Under its new name, and along with six other enamelware companies, it was involved in a 1912 lawsuit known as the "bathtub trust." Over time, production transitioned to a wide range of metal parts, and the company changed ownership again, becoming Noblesville Casting. The image below depicts the company's foundry around 1968. (Above, HCHS–Roberts Collection; below, Sherry Faust.)

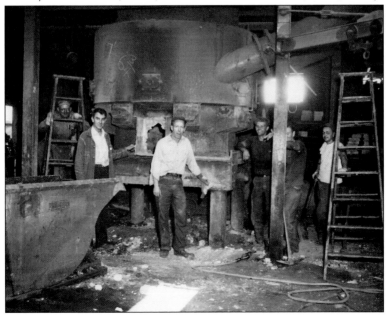

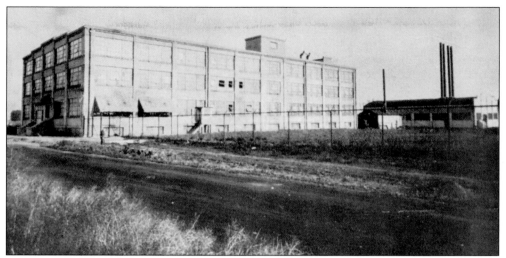

Burdick Tire and Rubber Company first operated out of the Heylmann Building in Noblesville. In 1920, Burdick moved to a new four-story building on Division Street. The plant was later sold to Steinbrenner Rubber Company. When Steinbrenner went into receivership in 1928, the plant was sold to Schacht Rubber Company. Schacht operated out of this building until it was sold to Firestone in 1936. (Gerry Hiatt from the Reed and Steve Miller Postcard Collection.)

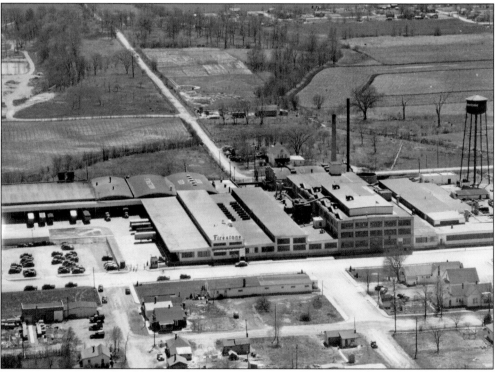

For many years, one of Noblesville's largest employers was Firestone Industrial Products, located at 1700 Firestone Boulevard (a renamed block of Division Street). Firestone produced molded industrial rubber products, tank tracks, and air-suspension springs, but no automobile tires. The plant closed in 2009, and the building was demolished in 2011. This aerial view of the plant dates to the 1940s. (HCHS.)

Six

Life in Noblesville

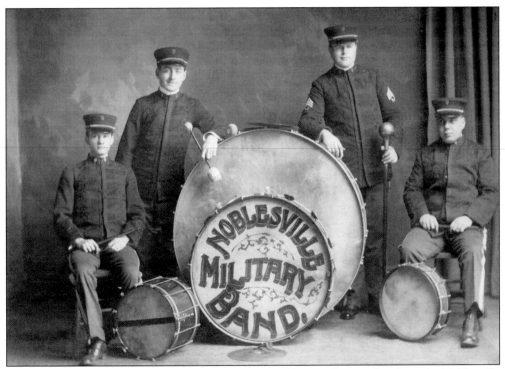

The Citizens' Band and the Grand Army of the Republic Band merged to form the Noblesville Military Band in 1889. There were about 18 members in the original band with George Shirts as the leader. In 1901, the band became incorporated, and in 1902, member Meade Vestal succeeded Shirts as conductor. For many years, it was customary for the band to play at the graves of former members on Decoration Day, now known as Memorial Day. The band not only had the support of the city, it also was a source of great pride for the residents of Noblesville. Pictured is the percussion unit in the 1920s. At the time of this photograph, there were over 45 members. (HCHS.)

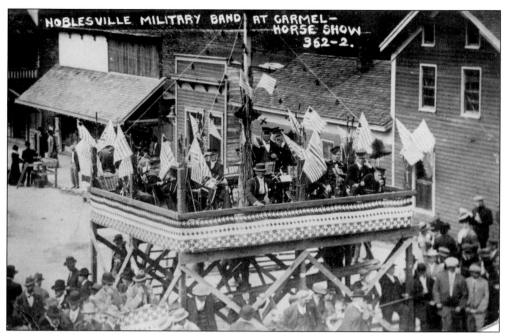

For many years, the Noblesville Military Band gave indoor and outdoor concerts, attracting thousands of people to town. The band participated in parades in Noblesville and Indianapolis and even made trips for out-of-state performances, notably traveling to the Republican National Convention in Chicago in 1908. Here, the Noblesville Military Band gives a concert at the Horse Show in neighboring Carmel, Indiana. (Paula Dunn.)

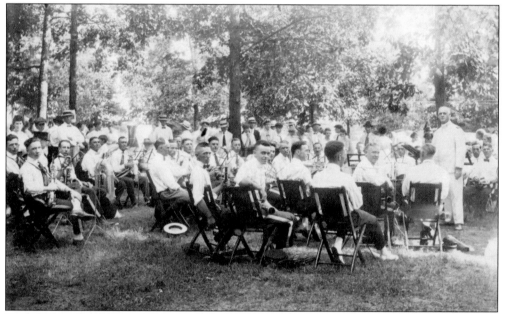

The Noblesville Military Band prepares to give an outdoor concert in the 1920s, with Meade Vestal directing. Jacob D. Hill, president of the band's board and active band member, is one of the men ready to perform. Hill's skill and energy contributed greatly to the successful training of the band. (Paula Dunn.)

Prior to construction of Leonard Wild's opera house, a livery stable occupied this site on Catherine (now Ninth) Street. The opening performance was the play *Charley's Aunt*, given on November 25, 1895. People eagerly attended the magic lantern (slide projector) and stage shows. Leonard Wild's second wife, Martha Coffin Wild, rarely missed a performance. The building also hosted Noblesville High School graduations, political events, music concerts, and even film showings around the time of World War I. (HCHS–Roberts Collection.)

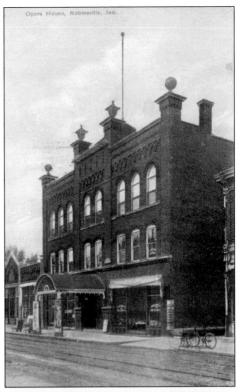

The opera house was well built, with brick walls four layers thick and firewalls between sections. The front section was a three-story building with stores and meeting rooms. The second section was the auditorium, and the third was the stage and fly space. The November 1929 photograph below shows a performance of the play *Dulcy* being given by the Noblesville Little Theatre Society. The Little Theatre Society was "not a charitable, but a dramatic organization attempting to present a few of the better plays of recent years." (Kurt Meyer.)

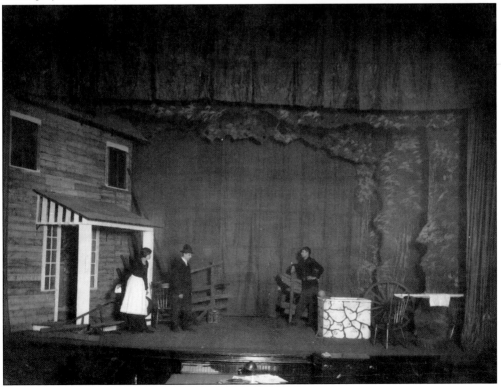

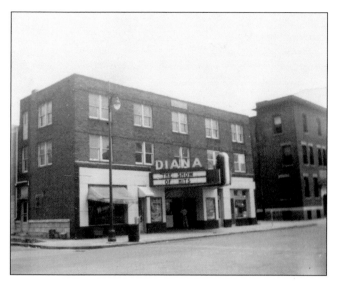

Noblesville's first theater with a projection room opened as a "photoplay" house on March 22, 1920, under the name American Theatre. Located on North Ninth Street, it closed less than two months later but reopened under new management as the Olympic Theatre on May 8, 1920. It was also known as the State Theater before becoming the Diana Theater in 1938. A leaky roof prompted its closing in July 1978. Wimpy's Grill can be seen to the left of the marquee. (Ruth Hall Lusher.)

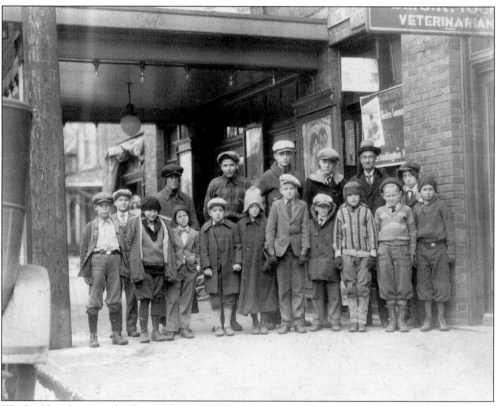

The building housing the Diana Theater also held three small businesses, including the newsstand of John H. Wise, co-owner of the building. Standing underneath the marquee of the Olympic Theatre is Wise with the boys who delivered his newspapers. This 1926 photograph depicts one of the many marquees the theater had over the years. At one time, the Greyhound bus station also shared space in the building. (Jane Cullen Gawthrop.)

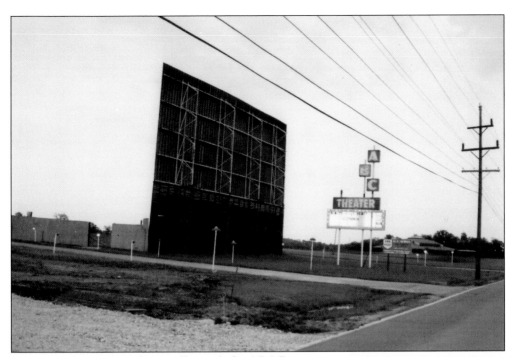

When Cumberland Road was still gravel, the ABC Drive-In (originally called the Noblesville Drive-In) opened on May 30, 1951, with room for 300 cars. In the early 1960s, it was expanded to hold 700 cars, the screen was widened, and the projection equipment was updated. The drive-in season was from May to mid-November. This photograph was taken just before this icon of Noblesville history was put up for sale in 1996. (John W. Green.)

Grand-opening ads enticed people to "bring the baby . . . we'll warm the milk." Moviegoers were encouraged to come as they were and enjoy movies in their car. As ownership of the drive-in changed, so did the name. When the theater first opened, the price of admission was 50¢ for adults, and children under 12 were free. Years later, the cost of admission for adults increased to $4, as shown on these tickets. (Steve Schwartz.)

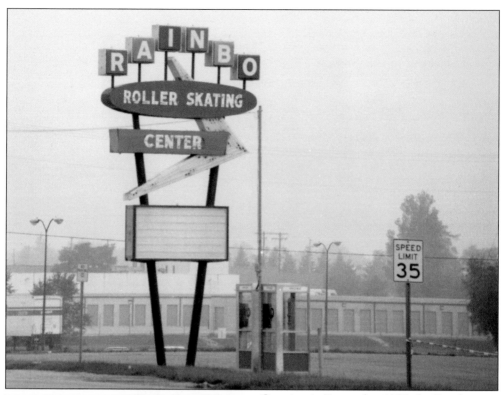

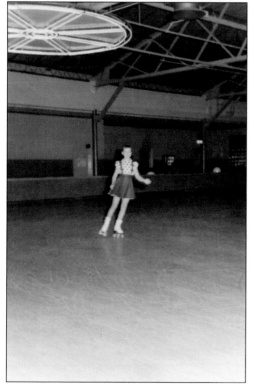

Opening in September 1955, the Rainbo Roller Skating Center provided years of pleasure to Noblesville's residents as the second largest rink in the state. Designed by A.A. "Gus" Faulstich and constructed by Lowell "Doc" Griffin and Everett Walston, the center also had a restaurant on the west, a drive-in on the south, and a meeting room on the east. A declining economy put it on the market, leading to its demise in 1989. (Dottie Young.)

A young Sherry (Whitesell) Faust skates on the hardwood-maple floating floor, which measured 200 feet by 90 feet. Circling the floor 13 times would equate to traveling one mile. Above the floor shone 5,000 linear feet of colored fluorescent lights, which blinked various colors corresponding with the music of the featured skate. Skaters were first accompanied by organ music, which was replaced by rock music in 1976. The Rainbo rink brought people to Noblesville from throughout central Indiana. (Sherry Faust.)

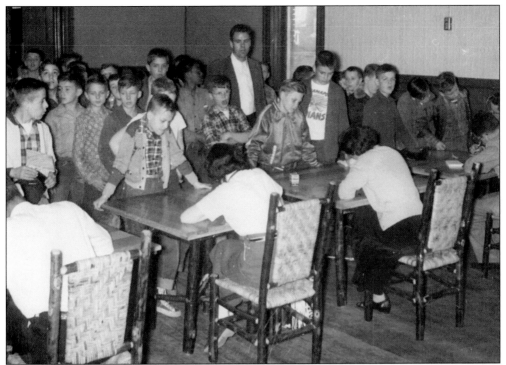

On April 16, 1953, when the Boys Club of Noblesville opened its doors, 61 boys enrolled. Known then as the Boys Club of Noblesville, only boys were eligible. Located on the third floor of the Knights of Pythias building, their motto was "Building the Citizens of Tomorrow." Renovations to the former fraternal facility included a full-size basketball court and woodworking facilities. In 1969, the club leased the Noblesville High School gymnasium on Conner Street. Girls were not admitted full-time until 1985 when the name changed to the Boys & Girls Club of Noblesville. Above, boys wait to register for the club, which originally cost 35–50¢ for one year, based on age. Below, basketball courts had replaced the high school classroom facility on Conner Street. (Above, Irv Heath; below, Boys & Girls Club of Noblesville.)

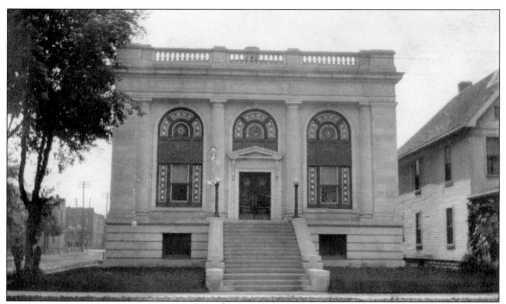

Built in 1914, this Masonic temple on South Ninth Street was designed by Don Graham of Indianapolis and reflects the Neoclassical style. The laying of the cornerstone was a festive daylong occasion, with hundreds of people lining the square to view the parade. Although the third site for the Noblesville Masons, this was the first used exclusively as a lodge. Most fraternal organizations were housed in the upper stories of downtown buildings. The existing lodge, Noblesville Lodge No. 57, was merged from two lodges in 1853. (HCHS.)

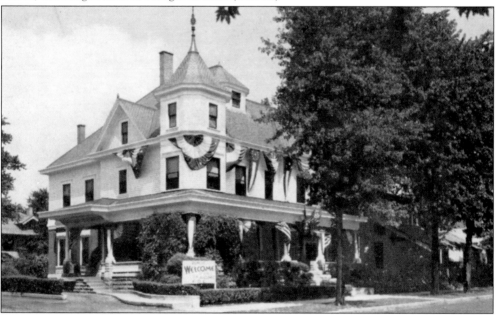

The Fraternal Order of Eagles Aerie No. 450 was organized on August 6, 1903, with 103 charter members. They first met in the Red Men's Hall. In 1935, they purchased the Jacob F. Heinzmann house pictured here, which was across Conner Street from the Elks' Lodge. In 1992, this house was sold to the American Legion, which demolished it. The lodge moved to its current location at 1565 North Tenth Street in 1995. (Steve Schwarz.)

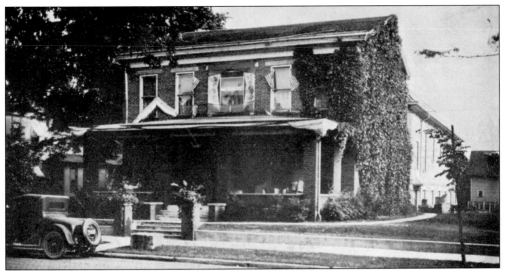

The Benevolent and Protective Order of Elks Club No. 576 was organized in May 1900, in the Knights of Pythias Hall, with 37 charter members. The club assisted charities on local, state, and national levels. This image shows the first lodge, the former Walter N. Evans residence on Conner Street, which the Elks purchased in 1916. This property was sold in 1972 and later demolished for a parking lot. (HCHS–Roberts Collection.)

The Lions Club received its charter on June 4, 1942. Fundraisers, like the annual pork chop dinner and pancake breakfast, are used to finance scholarships, support the Boys & Girls Club of Noblesville, and give to other charitable projects. Pictured here is a past fundraiser, a sale of citrus fruits. Receiving the fruit to distribute are, from left to right, Roy Kirk, Harlan Thompson, John Chenoworth, Francis Beck, unidentified, Jack Davis, and Irv Heath. (Jack Logan.)

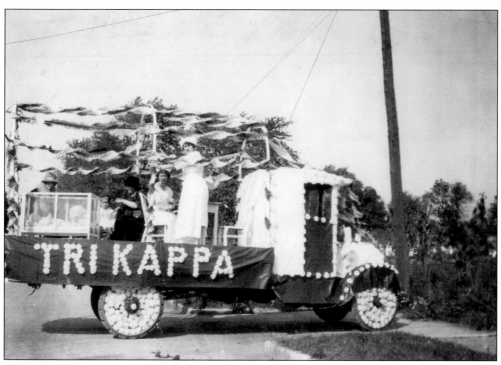

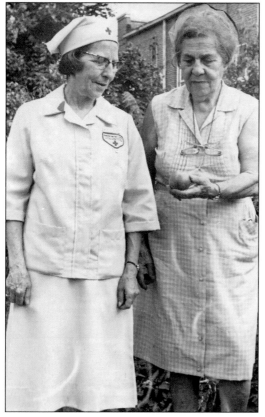

The Beta Epsilon Chapter of Kappa Kappa Kappa, also known as Tri Kappa, was formed in 1915. This women's philanthropic sorority exists only in the state of Indiana. Members of Tri Kappa promote charity, culture, and education, both locally and statewide. The group supports charitable causes through a variety of fundraisers. This photograph shows Tri Kappa's float in the 1923 centennial parade, with Louise (Neal) Conkle, Dorothy Mayne and her children Jean and Phyllis (sitting), and Margaret Hull (standing). (HCHS–Brooks Collection.)

The Hamilton County chapter of the American Red Cross was organized in Noblesville on March 28, 1917, under the leadership of Meade Vestal. In 1953, Ruth Essington, executive director of the local chapter, organized the Gray Ladies as volunteers at Riverview Hospital. Frances Heylmann (left), pictured with her sister Dale Gaddis, was certified as a Gray Lady after taking a course of instruction offered by the Red Cross. (HCHS–Essington Collection.)

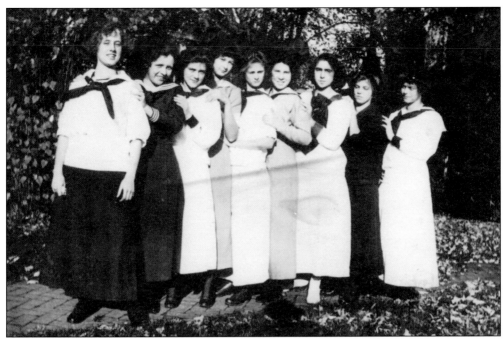

The Tourist Club was organized in September 1894. Its mission was to allow women to "travel" to various places while still remaining at home to care for their families. Members studied and discussed geography books to bring destinations to them. In their first year, they started in California, visited the Rocky Mountains, Mexico, Louisiana, New England, and the Gulf states, and ended with a comparison of the centennial of 1876 with the World's Fair of 1893. Pictured here are members from 1918–1919 when they studied World War I and its aftermath. (Heylmann family.)

The Neighborly Club was organized in 1890; the 10 charter members were Mrs. George Snyder, Mrs. Everett E. Neal, Mrs. George Christian, Mrs. Silas Hare, Mrs. D. Evans, Mrs. Ben Booth, Mrs. Frank Moss, Mrs. Ned Herron, Mrs. Al Clark, and Mrs. John Patterson. Mrs. Christian named this social club "Neighborly." It celebrated its 54th anniversary in 1944. This 1899 photograph features club members and their children. (Heylmann family.)

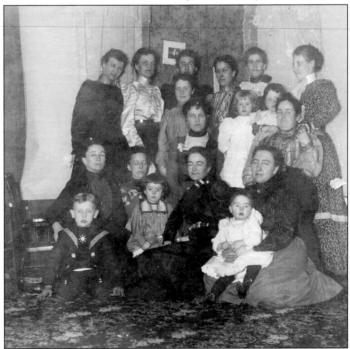

In 1922, Noblesville Heat, Light and Power Company completed a dam and hydroelectric power plant on the White River north of Noblesville. The resulting artificial lake was used as the centerpiece for a summer resort named Riverwood. From its first day, when more than 1,000 tourists visited, Riverwood was a magnet for residents of central Indiana. Automobiles were both affordable and practical, making Riverwood an easily accessible destination. (Heylmann family.)

Cabins (both rental and privately owned) were constructed at Riverwood for use in the warmer months. Many had names like Riverview Cottage, Sheffield Inn, and Sun Crest Cottage. The Heylmann family of Noblesville owned two cabins, Moon Glow and Wheel Inn. In this image, Dale Heylmann, oldest daughter of Frederick and Cora, enjoys a day at Riverwood with friends in the 1920s. (Heylmann family.)

Riverwood was the site of numerous family and school reunions, church gatherings, parties, club outings, and picnics. The Red Lion was a restaurant and dance hall, located across from the bathhouse at Riverwood. They also sold candy, ice-cold Coca Cola, cigarettes, ice cream, and frozen Milky Ways. Jim and Jane Gaddis are pictured enjoying ice-cream cones one summer day in the 1930s. (Heylmann family.)

Swimming, boating, and fishing were popular activities at Riverwood. This photograph shows the Gaddis children with family and friends enjoying the artificial lake. A bathing beach stretched more than one mile along the lake's shoreline. The resort was complete with boathouses, tennis courts, and other summer equipment. Fishing was common as the lake was stocked with crappies and largemouth and smallmouth bass. (Heylmann family.)

In 1925, Mayor Horace G. Brown resigned his office and, the following day, sold his 118-acre farm to the city of Noblesville for use as a city park (soon thereafter named Forest Park). In 1926, more than 12,000 trees and shrubs were planted on the property. The winding boulevard was developed in 1927 and 1928 with a gravel roadbed and stone entrances. Interestingly, in 1928, the most urgent need was for an adequate sanitary toilet system. Equipment for the first playground was paid for through an entertainment program held at the Wild Opera House. Casey Jones, seen below, was added to the park in 1976. It was constructed by street department workers. The steel, sandblasting, and paint were all donated. (Above, Sherry Faust; below, NPRD.)

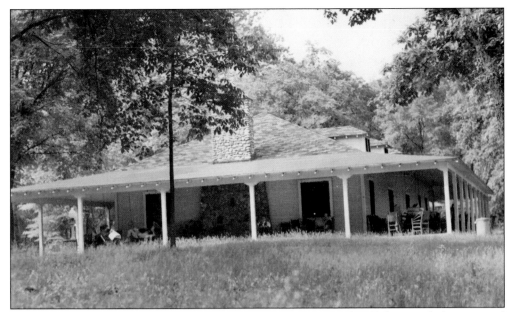

Forest Park Inn was constructed in 1926 as a one-story structure with a 12-foot porch that wrapped around the entire building. The original facility included a kitchen, cobblestone fireplace, and beamed ceiling. Constructed as a tourist camp shelter house, it was known for its Sunday chicken dinners. In 1955, an overlook room with views of the golf course was added. In 1998, the inn underwent a major renovation, which also enlarged the facility with office space. (HCHS.)

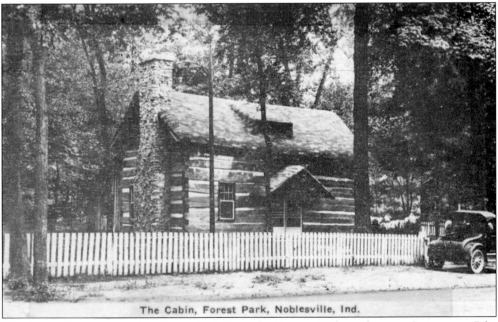

The Cabin, Forest Park, Noblesville, Ind.

This log cabin was moved to Forest Park from the George Webster farm on Stringtown Pike southwest of Cicero in 1928. It was known as the Cabin Club House and Museum of Forest Park. Unfortunately, the museum function did not endure, as visitors took the artifacts as souvenirs. The building had a full kitchen and could sleep 30 people upstairs. Over time, the cabin deteriorated and use declined. In 1997, because of its poor condition, the structure was demolished. (NPRD.)

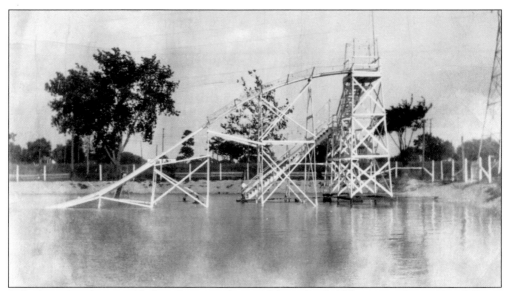

A bathing beach was added to Forest Park in 1926, in the field between Cicero Road (State Road 19) and the river, north of the railroad viaduct. Fed by the White River, the pool included a special area, nine to ten feet deep, for diving. In 1928, it was improved with slides and a water wheel. As a gravel-bottomed swimming area, the bathing beach was not entirely successful and was described as being a "mud hole." (Sherry Faust)

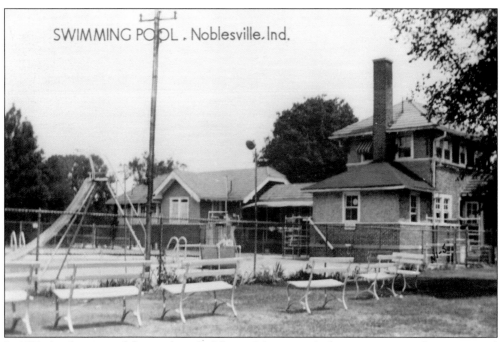

In 1931, development of the north end of the park began with the construction of a cement and tiled pool near the former Hamilton Chemical Company. Until the company closed, this area of the park was unusable due to the odor from the hogs. The bathhouse, seen here, was originally the main building of the chemical company. The swimming pool remained until the current Olympic-sized pool was built in 1975. The bathhouse was demolished in 2006. (NPRD.)

In 1926, Thomas Bendelow, respected golf course architect, designed the Forest Park Golf Course. Through monetary donations and volunteer labor, the 55-acre course was completed in 13 months, with 50 golfers teeing off on opening day (June 16, 1927). The image at right shows Dr. Joel Sturdevant and an unidentified friend enjoying a round of golf. Greens fees were 50¢ per day, or $7.50 for a season ticket. Play on Sunday was permitted, even in 1927. Golf quickly became a popular pastime, and in 1931, the Noblesville Millers High School golf team was formed. In 1938, an irrigation system was installed using reclaimed gas pipes buried on farms around Hamilton County. After the Fox Prairie Golf Course opened, the Forest Park course languished until being revitalized in the 1990s. (Right, Heylmann family; below, Sherry Faust.)

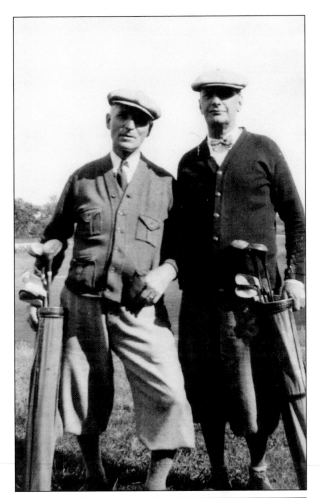

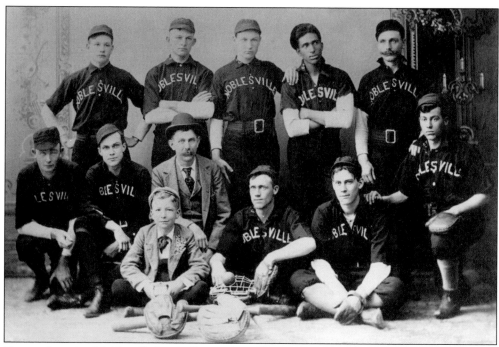

Shown above is a Noblesville baseball team from the 1890s. Pictured are, from left to right, (first row) Bill Pickrell, Harry Essington, Fred Deck (manager), Jim Gilchrist (bat boy), John Kerwin, Louie Darrah, and Ab Weldon; (second row) Larue Christian, Ernest Christian, Nev Curtis, Roy Roberts, and Jack Melvin. As manager, Fred Deck always promised that, win or lose, it was his intention to have some of the best baseball clubs play in Noblesville. In 1934, baseball managers, coaches, players, and sponsors organized the Hamilton County Amateur Baseball League at Forest Park. Eight teams were organized to play double headers on Sunday afternoons. Pictured below are boys from the Arcadia High School baseball team sponsored by W. Hare & Son. Bill Hare, a former baseball player, served as coach; Wayne Morehead acted as manager. (Above, HCHS; below, Hare family.)

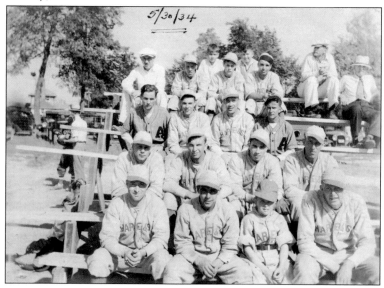

Seven

COMING HOME TO FAMILY

According to notes on this photograph, this image was captured around 1895, on Division Street. The ladies are Mayme Fryberger and Nellie Duckwall. Both ladies were born into large farm families in Noblesville Township in 1880. Although Mayme's father eventually worked for the school system as a truant officer, there is no record that either lady graduated from Noblesville High School. As adults, their lives took very different paths. Mayme never married and lived in Chicago for a short time before settling in Indianapolis, where she worked as a clerk in a department store. Nellie married William Garrard around 1907 and had one son, Lewis, in 1914. The couple divorced shortly thereafter, and Nellie later settled on a farm in Noblesville Township. (Kurt Meyer.)

The exact purpose of this photograph is unknown, but it likely shows a group of friends or high school classmates. The ladies are, in unknown order, Kate Ingerman, Stella Joseph, Lelia Vestal, Ella Truitt, Margaret Wild, Louanna Taylor, Louisa "Lula" Heylmann, Lula Fisher, Maud Messick, and Alice Hughs. All but three—Joseph, Hughes, and Wild—are listed in school records as graduates of Noblesville High School between 1889 and 1892. (Heylmann family.)

The gentlemen in this c. 1910 photograph were the second and third generations to join the family business currently known as Hare Chevrolet. At far right is Elbert M. Hare, eldest son of Wesley M. Hare. Also in the photograph are Elbert's own sons; they are, from left to right, Albert, Frank, and Willard "Bill" Hare. Although all three sons joined the family business, Albert also operated the Hare Petroleum Company in Noblesville, while Frank owned a Chevrolet dealership in Indianapolis. (Hare family.)

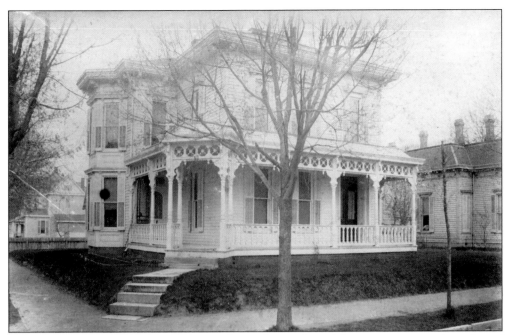

Constructed in the 1870s, this Italianate home featured an elaborate wrap-around porch and deep, bracketed eaves. Helen Thompson, wife of Dr. Henry H. Thompson, owned the home from 1909 until 1948. In the 1940s, the home was moved to the eastern half of the lot, and the original porch was replaced with a brick porch. A Sinclair service station was constructed in the original corner location. During the move, the home was not rotated to face Cherry Street, so now it seems to face the rear of the former gas station. (Pauline Wease.)

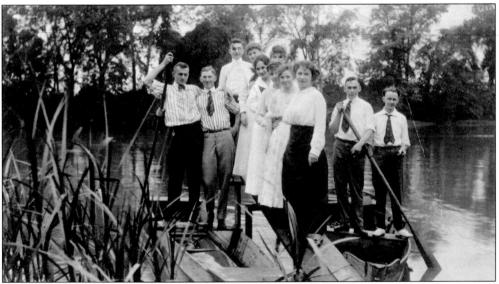

In this 1915 photograph, Noblesville High School friends and recent graduates gather together for a reunion. Dressed in their Sunday best, they are having a good time on the White River. They are, from left to right, Albert Tucker, Chauncey Craig, Kent Richey, Helen (Palmer) Tucker, Blanch (Carlin) Vestal, Evangeline (Jenkins) Owens, unidentified, Ruth (Caca) Call, Agnes (Klotz) Morris, George Bowen, and unidentified. (HCHS–Richardson Collection.)

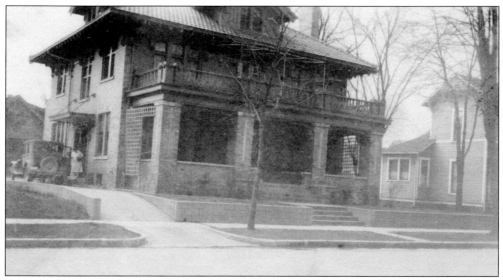

One of Noblesville's earliest brick schools was located where the Frederick E. and Cora Heylmann home now sits at 1083 Logan Street. Designed by Foltz and Parker, Indianapolis architects, the home was constructed around 1910 and reflects the Arts and Crafts architectural style. Around 1922, Herbert Foltz designed the one-and-a-half-story "auto house." Shortly after Frederick's death in 1925, Cora converted the home to two apartments. This configuration remained until 2011, when the house was sold out of the family and reverted to a single-family residence. (Heylmann family.)

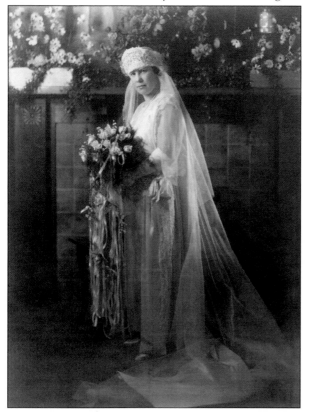

The Heylmanns moved into their Logan Street home with their three daughters, Dale, Frances, and Caroline. The beautiful home was the site of ladies' luncheons, club meetings, and other social affairs. In 1923, when Dale married Francis Gaddis, the couple's wedding reception was held there. The elaborate flower arrangements across the oak fireplace mantle in the parlor provided the background for Dale's bridal portraits. (Heylmann family.)

This photograph captures John George and Caroline B. Heylmann with their granddaughters Frances (seated), Caroline (middle), and Dale (standing), probably in the parlor of their Queen Anne home on the southeast corner of Tenth and Logan Streets. The girls were the daughters of John George and Caroline's son Frederick, and his wife, Cora. John George and Caroline had six children, but only three survived their parents. (Heylmann family.)

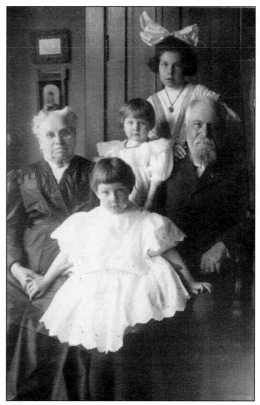

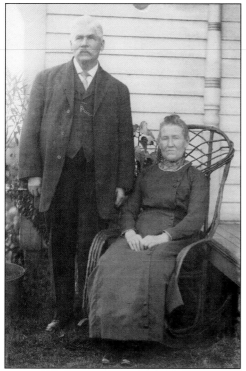

Charles and Susan Barth pose together in the early 1900s. Charles was a farmer in Noblesville and Jackson Townships. Born in Baden, Germany, in 1845, he immigrated to the United States and became a citizen in 1852. Charles married Susan Overlies on December 24, 1878, in Hamilton County. Charles was the brother of Caroline Barth Heylmann, wife of John George Heylmann. (Heylmann family.)

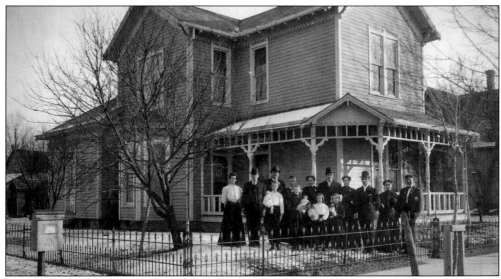

On the southeast corner of Tenth and Harrison Streets stood the Hawkins-Mabee-Cullen home, built in 1896 by Maria Hawkins. This 1902 photograph shows the family gathered outside the house for a Christmas celebration. Pictured are, from left to right, (first row) four granddaughters of George and Margaret Hawkins; (second row) Ruth Hawkins, Edward Hawkins, George "Gran'pa" Hawkins, Margaret Hawkins, Minnie Watson, Charles Watson, Fairy Mabee, William Mabee, Daisy Cullen, and William D. Cullen. The family is standing where Gran'pa's Popcorn and Candy Store now sits. (Jane Cullen Gawthrop.)

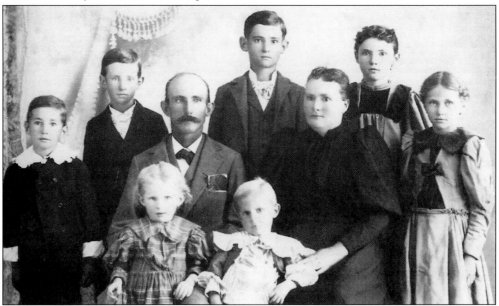

This 1895 photograph shows the Perry M. Hall family. They are, from left to right, (first row) Grace and Walter; (second row, seated) Perry and Laura; (third row, standing) Harry, Leonard, Harley, Nellie, and Myrtle. Born Benjamin Harrison Hall in 1889, Harry worked on his father's farm until marrying Ruth Dill in 1914. He moved to Noblesville about 1920. In 1938, Harry owned and operated the Hall Feed and Seed service station. He later worked as a plumber until his death in 1949. (Ruth Hall Lusher.)

Pictured here is the family of Jacob D. Hill. Dorthea (Spener) Hill, Jacob's mother, is in the front row at far left. Beside her is Jacob's daughter, Opal. In the back row, siblings and their spouses surround Jacob (second from right) and his wife, Cora (Goodwin) Hill. Over the years, Jacob served as chief of police, county clerk, and president of the Noblesville Military Band. (Paula Dunn.)

Located at 208 North Ninth Street, the Essington House was constructed by Martha Essington in 1891. After her husband's death in 1879, Martha supported her family as a milliner, and was later joined by her daughters in the business. Her son Harry lived in this home with his wife, Ruth. Ruth was a nurse at the Harrell Hospital, having studied nursing under Dr. Samuel Harrell. The home remained in the Essington family until Ruth's death in 1987. (HCHS–Essington Collection.)

The Harrell House on North Tenth Street is an ornate Queen Anne home listed in the National Register of Historic Places. Built in 1898, the house is situated on two city lots and features a polygonal tower, stained glass, and a porte-cochere. The home's south side entry has "S. Harrell M.D." incorporated into the stained glass. Patients entered through this door to see Dr. Harrell, who had offices in his home. In addition, a speaking tube connected the side hall with the doctor's upstairs bedroom for late-night emergencies. In this photograph, taken in the early 1900s, the south end of the front porch has not been enclosed. Vivian (Voss) Harrell, the doctor's widow, lived here until her own death in 1959. The home remained in the family until 1970. (John Elliott.)

Eight

Cars, Buggies, and Bridges

Constructed between 1870 and 1871 by Josiah Durfee, Potter's Bridge is located at a spot on the White River once known as Potter's Ford because of its proximity to William A. Potter's farm. Durfee was a bridge contractor and partner in the firm Williams, Giger and Durfee. On the 1870 census, his household included 10 bridge carpenters, likely at work on this structure. Potter's Bridge is 246 feet long and is a Howe Truss design. In 1913, the floodwaters from the White River rose four feet above the bridge floor. Used for vehicular traffic until 1971, the road was later re-routed around the bridge, which remains in its original location and is now surrounded by a park. The bridge has undergone significant repairs and restoration twice, in 1938 and 1999. Potter's Bridge was listed in the National Register of Historic Places in 1991 and recognized with an Indiana Historical Bureau marker in 2007. (Heylmann family.)

The "Old Wagon Bridge," also known as the Logan Street Bridge, was the first span in Noblesville. It was constructed by John Atkins and Cyrus Durfee in 1867, and opened in 1868. The bridge was a Howe Truss of two spans and was 806 feet in length. When the Conner Street Bridge opened in 1931, this older structure was closed. It was later replaced by an iron bridge in 1933, which was replaced by a cement one in 1986. (HCHS–Meyer Collection.)

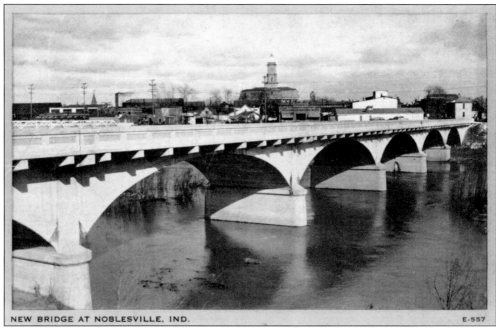

NEW BRIDGE AT NOBLESVILLE, IND. E-557

This postcard shows the "new bridge" on Conner Street. The bridge consisted of six spans, was 720 feet long, and was built of reinforced concrete; it was said to be one of the largest structures of its kind erected by the State Highway Commission in Indiana in 1930. Some residents felt the bridge would make it more convenient to reach Forest Park, which opened in 1926, and often called it "the bridge to Forest Park." (Heylmann family.)

WHITE RIVER NOBLESVILLE, IND.

From its beginning in a farmer's field in Randolph County, the White River flows in two forks, east and west, through most of central and southern Indiana. It has been said that the White River was named for the many white sycamore trees that once lined its banks. Life in Noblesville, located on the west fork of the White River, often revolves around this major geographical feature. Over the years, it has both physically divided the community and, during times of flood, threatened the community's very existence. It has also been central to many commercial enterprises (an early example being Conner's Mill) and leisure activities. Pictured below, Jim Gaddis and Jack Schmidt are among the many people to have taken advantage of the recreational opportunities of the White River, which include canoeing, fishing, boating, and swimming. The hydroelectric dam on the river provided both power and recreational activities. (Above, HCHS; below, Heylmann family.)

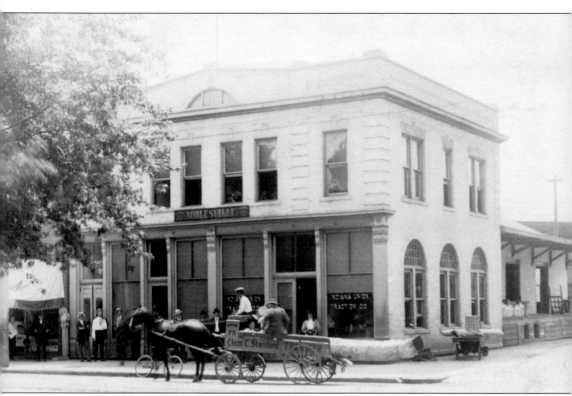

This image shows the Noblesville station of the Indiana Union Traction Company at North Ninth and Clinton Streets. The station was constructed around 1906, just three years after the interurban route was completed through Noblesville. Much of the line was constructed using an Italian labor pool that lived in camps, which moved with the construction of the lines. The Noblesville station contained a passenger waiting room, administrative offices, and commercial space. A freight depot (visible on the right) was located in the rear. Operating on electricity, the interurban was an economical, convenient means of transportation between cities and towns in Indiana for 40 years. During its heyday, 35 of its trains passed through Noblesville each day. The advent of affordable automobiles, however, signaled the demise of the interurban. In the 1920s, passenger numbers declined significantly, and bus service for passengers and truck service for freight began replacing the interurban routes. Interurban service through Noblesville ended in 1938. (HCHS.)

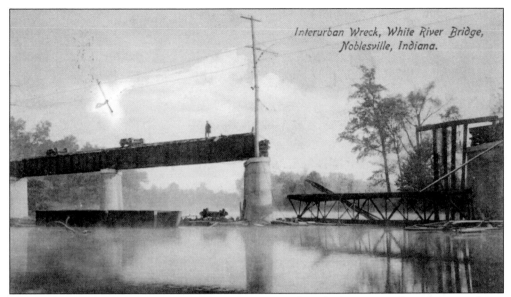

Interurban Wreck, White River Bridge, Noblesville, Indiana.

During the interurban's operation, newspaper accounts described a variety of accidents involving it, including passengers falling from the cars, pedestrians and automobiles being hit by it, and wrecks like the one shown here. In a separate incident, an interurban from Indianapolis jumped the tracks and rolled over onto automobiles on the east side of the square in May 1919. Robert Wiggins, an eight-year-old boy, was killed and more than 20 others were injured. (Gerry Hiatt from the Reed and Steve Miller Postcard Collection.)

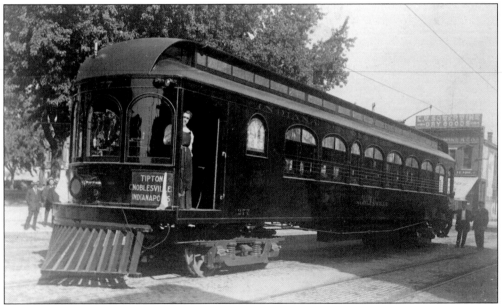

Interurban trains traveled through Noblesville carrying passengers, United States mail, and freight. In 1925, the service unveiled new, all-steel interurban cars with cushioned seats, large windows, individual lights, and arm and foot rests. Certain routes also had parlor cars with buffets and a clubroom for smoking. In this photograph, station manager Mary Little stands in the front of an interurban car sitting on the east side of the courthouse, between Logan and Conner Streets. (HCHS–Roberts Collection.)

The first railroad through Noblesville, the Peru and Indianapolis Railroad, arrived in 1851, the same year the town was incorporated. At left, a young girl stands on the railroad tracks where they entered Noblesville on the northwest side. After crossing the White River, the tracks ran south through town along Eighth Street, known then as Railroad or Polk Street. Local businesses sprang up along this street, many serving the needs of the railroad and its passengers. Industrial enterprises were in close proximity to the tracks, with railroad spurs for ease in shipping. The photograph below shows a spur connecting the enameling works near South Eighth and South Streets with the main rail line. Other railroad lines, including the Lake Erie and Western Railroad and the Midland/Central Indiana Railroad, also ran through Noblesville. (Left, HCHS; below, HCHS–Roberts Collection.)

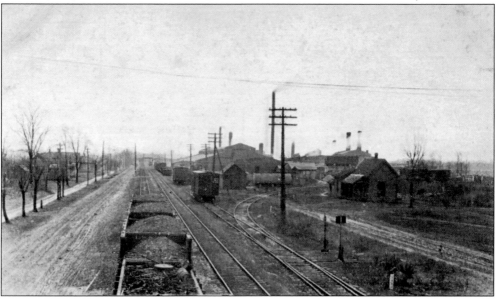

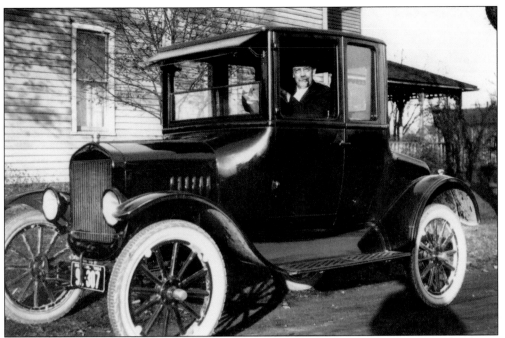

John Fisher, pictured in 1925, sits at the wheel of a Ford Model T owned by his son Roland. The vehicle had all the extras: lock-steering wheel, demountable rims, electric starter and lights, quick-change transmission bands, heater, and a water pump. (HCHS–Fisher Collection.)

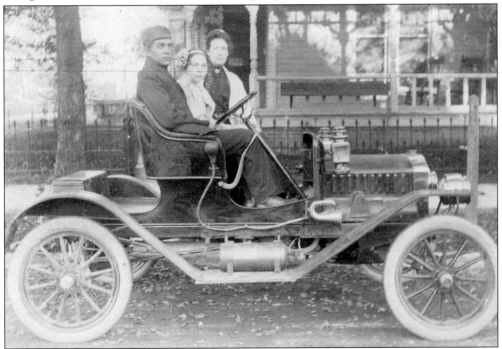

William and Fairy Mabee and their only child, Margaret, pose in their car (make and model unknown) in front of their North Tenth Street home. Margaret, who was born in 1898, never married. She predeceased her parents in 1928. (Jane Cullen Gawthrop.)

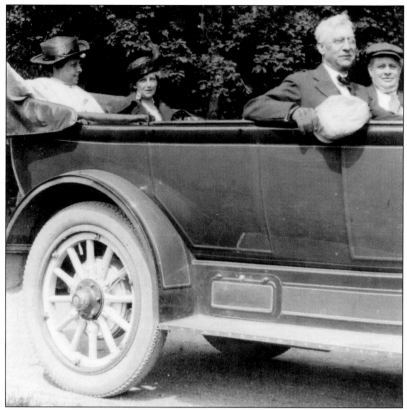

Frederick E. Heylmann spent his adult life manufacturing wagons, buggies, phaetons, and accessories for horse-powered transportation, a trade he learned from his father, John G. Heylmann. As automobiles emerged, Frederick apparently accepted the new mode of transportation. Above, Frederick is a passenger in an early automobile. In the 1910s, he employed George Mills as a car salesman and sold automobiles (Maxwells and Hupmobiles) alongside buggies in his Conner Street showroom. In 1913, a new law required owners to register their automobiles and motorcycles and pay a tax (ranging from $2 to $20). The owners received a number for their vehicle. The Indiana motor vehicle registration below was for the De Luxe Sedan Hupmobile Frederick and his wife Cora purchased from George Mills and Sons in May 1925. Note the misspelling of Heylmann on the registration. (Both, Heylmann family.)

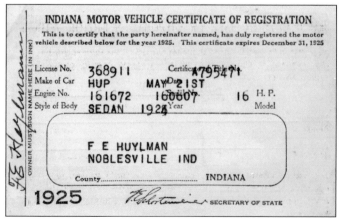

104

Nine

REMEMBER WHEN . . .

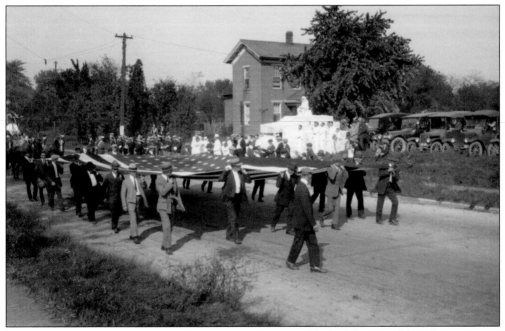

Mayor Horace Greely Brown declared October 3, 1923, a public holiday in Noblesville, requesting that all businesses and factories close during the centennial parade so that everyone could attend. The start of the parade formed on North Tenth Street at the intersection with Harrison Street, near First Ward School, and headed south towards the town square. This photograph shows 20 well-dressed men carrying a 20-by-38-foot flag, the largest ever seen in the city. City schools were closed so students could participate in or watch the parade. However, the school buildings were left open for the comfort and convenience of the people attending the day's events. The parked cars sit on the site now occupied by North Elementary. (HCHS–Brooks Collection.)

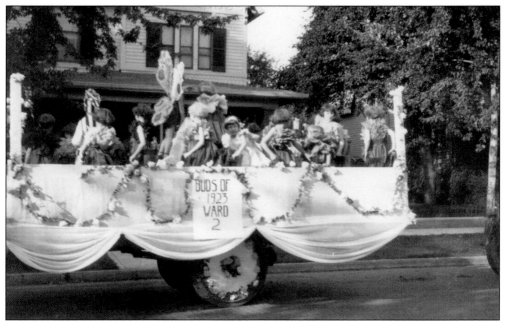

The "Second Ward Buds" float, which won first prize for the city of Noblesville, was created by the parents and teachers of the school's primary department. The waists and shoulders of each child are covered with decorations meant to resemble the leaves on a rose that cover the buds just before they are ready to bloom. Only the faces and curly hair of the children could be seen. (HCHS–Brooks Collection.)

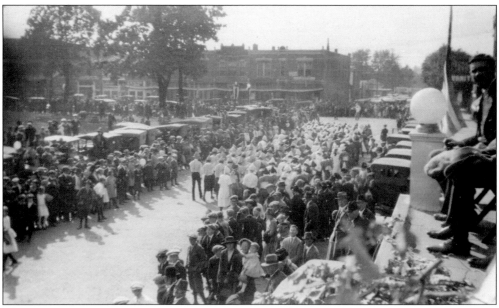

The local paper gave 20,000 as a conservative estimate of the size of the crowd (one third of whom were school children) that came out to celebrate Noblesville's and Hamilton County's centennial. As shown here, the town square was almost a solid mass of people as the parade marched down Logan Street to turn left onto Eighth Street. Over 300 floats and parade units took an hour and fifteen minutes to pass a given point. (HCHS–Burgess Collection.)

At the midday dinner hour on the second day of celebration, folks enjoying exhibitions and games shared in the "pitch-in" dinner. Logan Street was closed for this event. Three ministers gave grace for this shared meal, while three high school orchestras provided music to feed the soul. A huge, four-foot-high birthday cake, weighing 125 pounds and covered with 100 candles, waited to be cut. (HCHS–Brooks Collection.)

The birthday cake was to be cut by the oldest living woman and man in the area, Anna Gascho (98 years old) and Clark Millikan (100 years old), seen here. Anna Gascho was the widow of Henry Gascho and died in 1927. Born in North Carolina, Clark Millikan moved to this area after the Civil War and began farming the land; he died in 1926. (HCHS–Brooks Collection.)

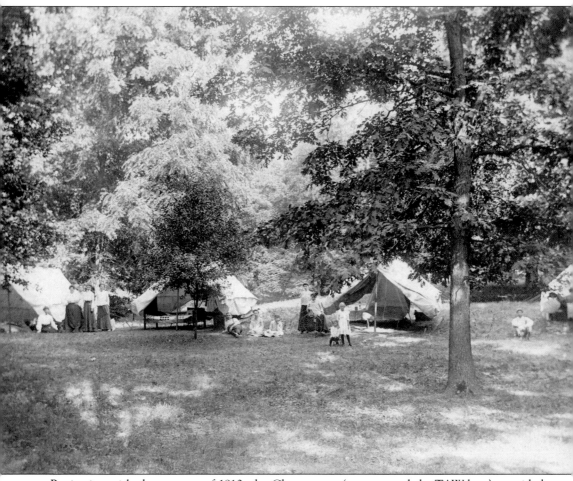

Beginning with the summer of 1910, the Chautauqua (pronounced sha-TAW-kwa) provided Noblesville with cultural, educational, and social activities for adults. Programs included lectures, concerts, and theatrical productions. The very first one was in Brown's Woods, located near Forest Park. A couple years later, the Chautauqua moved to Hines' Grove (seen here), located south of the former site of Firestone Industrial Products and west of the Walmart Supercenter. In 1926 the site changed again, moving to the horse show grounds, which were located across the street from First Ward School. Everyone in town attended, with some families camping on the grounds. The Chautauqua was an eight-day event, usually held in August, from 1910 through 1926. By 1927, Forest Park attracted more and more people. Since the park provided year-round entertainment, interest in hosting a week-long entertainment venue declined and the Chautauqua ceased to exist. (Paula Dunn.)

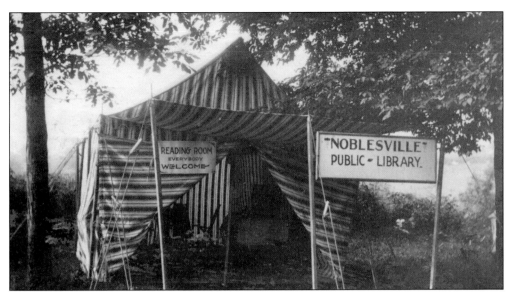

At the 1915 Chautauqua, the Noblesville Library set up a Reading Room tent on the grounds, inviting patrons to use this space when not otherwise engaged in scheduled activities and events. This same year, Helen Keller was one of the lecturers, inspiring one of the largest crowds ever to attend a Chautauqua. In her honor, the public library closed early so that all could attend her lecture. (HEPL.)

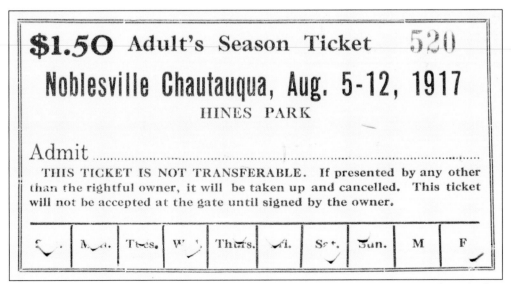

For $1.50, the holder of this season ticket could enjoy concerts, lectures, and events for eight days at the 1917 Chautauqua. It would be a treat from beginning to end. For this small amount of money, the ticket holder would have the opportunity to hear incredible speakers, like Rev. L.E. Brown and Dr. George R. Stuart, and enjoy great musical entertainment of all kinds, including the Duggin Grand Opera Company, Thatcher's Chicago Symphony Orchestra, and the Noblesville Military Band. (HEPL.)

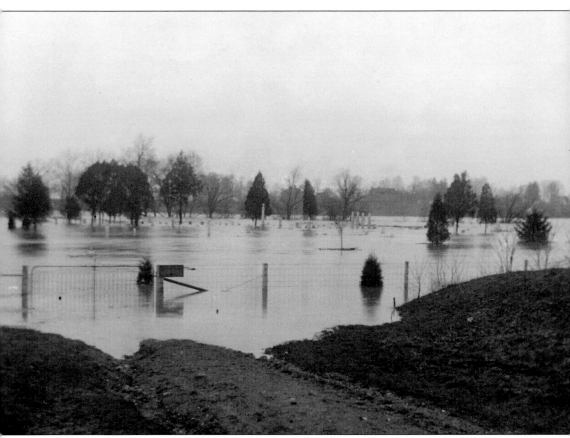

Although Noblesville has experienced multiple floods, the flood of 1913 threatened the city like no other. On March 25, 1913, the White River crested over nine feet above flood stage, practically cutting off Noblesville from the rest of the state. Roads were damaged, bridges were either washed out or weakened, and telephone lines were downed. The city's business district was threatened for the first time in history as the river overflowed its banks. Residents were without fire protection when the water works closed. The lack of electric service plunged surviving homes into darkness. Floodwaters submerged the old Riverside Cemetery at the west end of Cherry Street, knocking down fences and monuments, disturbing graves, and washing out the cinder driveways. Some monuments were recovered miles down the river. Today, these recovered pieces lie fixed in a cement area in the cemetery. This photograph shows Riverside Cemetery under floodwater. (Gerry Hiatt from the Reed and Steve Miller Postcard Collection.)

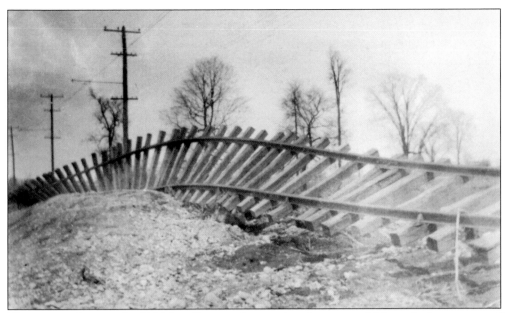

The traction line north of Noblesville was submerged under water, which washed away most of the grade and damaged the track. Bags of sand were piled three feet high to form a levee on the west side of the traction line, midway between the interurban substation and the end of the brick pavement on North Ninth Street. It was several days before the interurban track was repaired and traffic could resume. (HCHS–Fisher Collection.)

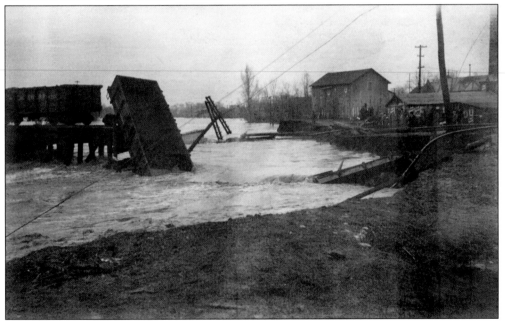

To keep the Lake Erie & Western Railroad Bridge from washing away, coal-loaded railroad cars were placed on it in hopes that the weight would secure the bridge on its foundation. Floodwater washed away the riverbanks as it struck the iron framework beneath the bridge. Unfortunately, the water proved to be too much, and the bridge gave way, dumping two cars into the river. (Gerry Hiatt from the Reed and Steve Miller Postcard Collection.)

SECOND ANNUAL DANCE

K. OF P. ARMORY

𝕶𝖚 𝕶𝖑𝖚𝖝 𝕶𝖑𝖆𝖓

TUESDAY EVENING, AUGUST

TWENTIETH, NINETEEN

HUNDRED TWELVE

ONE BEAN STAGS BARRED

As early as 1910, the Ku Klux Klan was more of a social "club" in Noblesville than a political force, as evidenced by this 1912 admission ticket to the second annual dance at the Knights of Pythias Hall. In the early 1920s, the Klan had a substantial presence in Noblesville. It was often viewed as a social organization that espoused Americanism. However, some members threatened boycotts of businesses if the owner did not join the Klan. Members were asked to sign an oath card, as shown below. In the summer of 1925, a Hamilton County jury composed of local Noblesville residents found D.C. Stephenson, grand dragon of the Indiana Klan, guilty of second-degree murder. The trial and its resulting verdict signaled the demise of the Klan in Noblesville and Indiana. (Above, anonymous donation, below, HCHS.)

We, the following Native Born Citizens of the United States of America, believing in the Constitution of our American Government and for the best interests of our Nation at heart, respectfully submit our signatures as evidence that the undersigned individuals are of unquestionable character and are loyal American Citizens.

Zeckel's Clothing Store, on the south side of the square, undertook an expansion of the shoe department in 1952. Workmen were pouring concrete in the basement on January 8 when the west wall suddenly collapsed, and all three floors came down. The first floor dropped a few inches initially, and it was about 10 minutes later that the major collapse of all three floors occurred, giving precious time for people to evacuate the building. Amazingly, only one person in the building at the time was injured, and no one was killed. It is believed that the small floor supports that were used could not hold the weight of the brick building. The International Order of Odd Fellows lodge on the third floor was reduced to rubble. Surrounding structures were also damaged and weakened by the collapse. (Both, Irv Heath.)

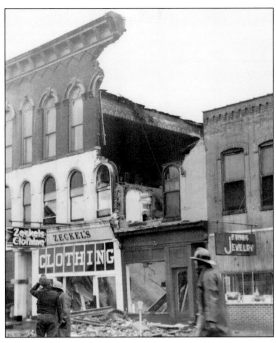

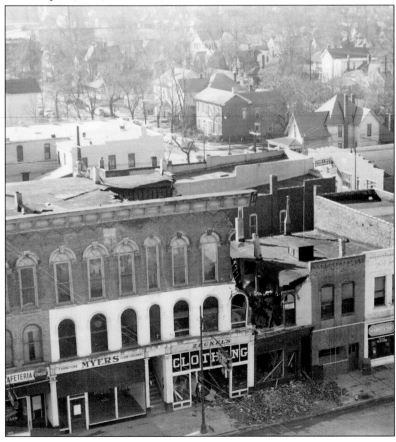

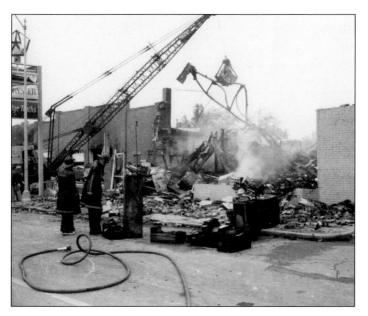

This fire occurred on October 13, 1967, at the Goeke Dodge-Chrysler dealership on Conner Street. Nineteen fire departments in central Indiana assisted the local fire department in battling the blaze, which destroyed half of a city block. More significantly, the fire claimed the life of Raymond E. Moulder, assistant chief of the Fishers Volunteer Fire Department. (Noblesville Fire Department.)

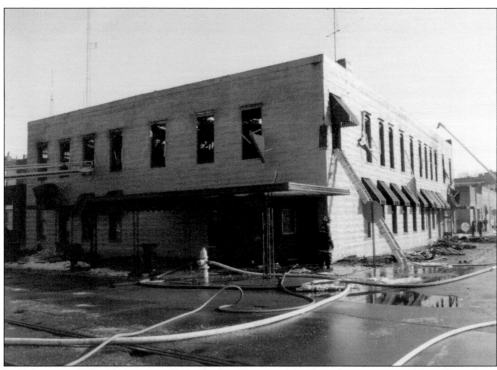

In February 1984, a fire swept through the Houston Hotel in downtown Noblesville. Three residents were killed, making it the deadliest fire in Noblesville's history. The blaze started on the second floor and destroyed much of the building. The remnants of the Houston Hotel were later razed. The building had been a fixture on South Eighth Street since the turn of the century. (Noblesville Fire Department.)

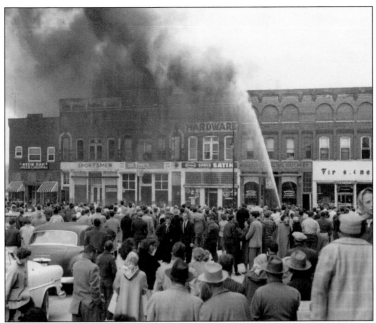

In these images, thick, black smoke is seen billowing from downtown buildings on March 24, 1957. The fire, which started in Todd's Feed and Seed Store, destroyed three businesses as well as the Moose Lodge on the north side of the downtown square. The local fire department was assisted by fire departments from Tipton, Westfield, Sheridan, Carmel, Lawrence, and Anderson. The fire also heavily damaged adjacent businesses. The Noblesville Hatchery lost unhatched eggs and 5,000 chicks. The remains of the burned structures were subsequently razed and replaced by new commercial buildings. Since the fire department's formal organization in 1901, only one Noblesville firefighter has died in the line of duty. Volunteer fireman Byron Galbreath was electrocuted fighting a fire in the Louis Smith Junk Yard in 1951. (Both, Irv Heath.)

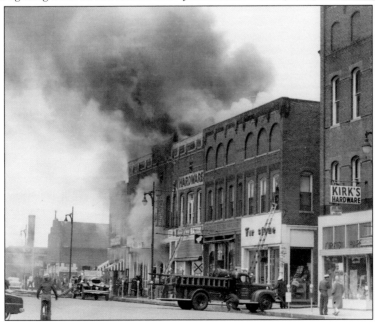

The Craig House at 1239 East Conner Street was built in 1893 by William H. Craig. On March 5, 1988, this three-story brick house made Noblesville history when it was moved across the street. Earlier, in October 1987, the First Presbyterian Church (which owned the Craig House) decided to expand eastward on its property. Sandi and George Elliott bought the house and hired the Elmer Buchta firm of Otwell, Indiana, to move the structure to its new address at 1250 E. Conner Street. On the day of the move, with sunny, 50-degree weather, hundreds of people gathered on Conner Street to watch as the 300-ton building inched across the street to its new location. (Both, FPC.)

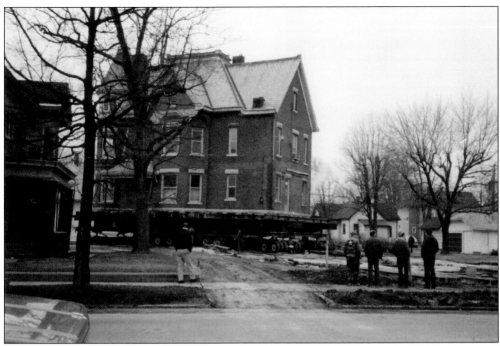

Conner Street was closed to traffic for the day as the Craig House slowly moved across the street over a period of eight hours. Railroad ties and hickory boards were used in the process in order to protect the surface of the street. The house was supported by 100 tons of steel beams as huge winches moved it across the street. It took two days for movers to turn the structure at its new location, using 10 dollies with a total of 104 tires underneath. Shown below is the vacant lot where the Craig House once stood beside the First Presbyterian Church. The home's removal opened the east side of the church to the sun after almost 100 years. (Above, Nancy Massey; below, FPC.)

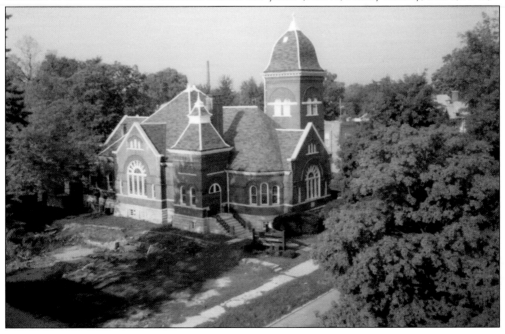

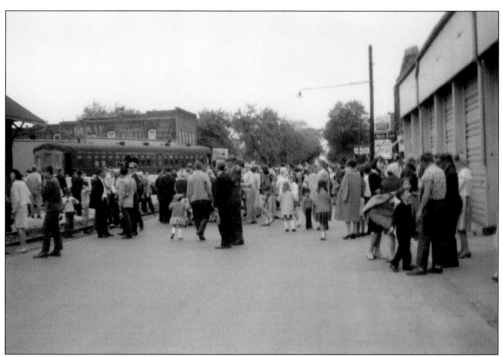

Before airline travel became common, political campaigns often utilized railroads, with whistle-stop tours through cities and towns along the train tracks. The Presidential Special visited downtown Noblesville on October 15, 1948, carrying President Harry S. Truman on a campaign tour of the Midwest. Thousands gathered near the corner of South Eighth and Conner Streets to hear his brief address directed to farmers. Hamilton County Democratic Party representatives, including Noblesville's own Dale Gaddis, presented orchids to First Lady Bess Truman and the couple's daughter, Margaret. They then joined the entourage, traveling to Marion County for an event in the capital city that evening. Other stops on the Trumans' tour included Kokomo and Tipton. (Above, Thelma Clark; below, Sherry Faust.)

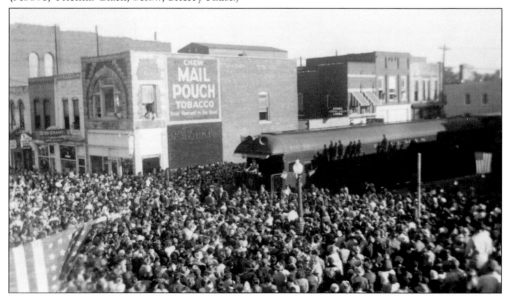

Ten

GONE BUT NOT FORGOTTEN

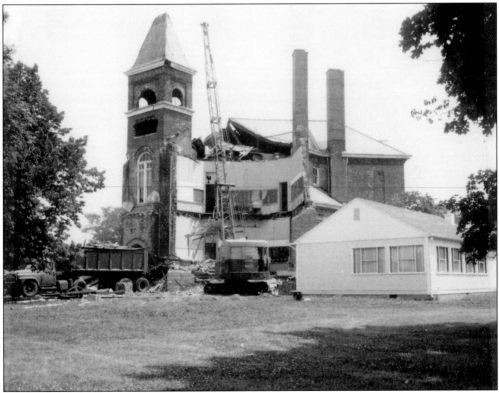

Constructed in 1888–1889, First Ward was a grand brick school at Harrison and North Tenth Streets. As early as 1945, the school board was advised to construct a new school on this block and cease using this building. Still in use in the 1960s, however, this substantial brick structure was insufficient to adequately educate students in the growing city it served. One-story auxiliary structures helped with the overflow of students, but were not a permanent solution. The construction of North Elementary on the north side of First Ward signaled the demise of what was once a symbol of pride in the community. During the summer of 1967 the wrecking ball was brought in, and a building that had seen thousands of students pass through its doors was no more. (Irv Heath.)

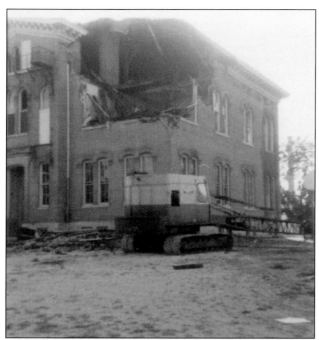

After 98 years of service to the school system, Second Ward succumbed to the wrecking ball in 1969. During its long history, the building housed every grade from first through high school. Sadly, what was once a source of pride no longer had a role in the future of the community. In the fall of 1968, its elementary students joined Third Ward students at the newly completed Stony Creek Elementary on Greenfield Avenue. (Sherry Faust.)

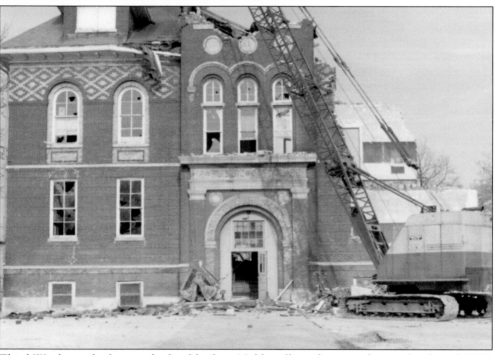

Third Ward was the last ward school built in Noblesville and was used as a school until 1968. In 1945, an inspection report on school facilities recommended this building be "modernized" for continued use. Improvements were made, but 20 years later, long-term plans called for its abandonment. Taken in April 1969 as the wrecking ball destroyed the elegant brickwork and hipped roofline, this picture shows the demise of what was once a fundamental part of the Noblesville school system. (Sherry Faust.)

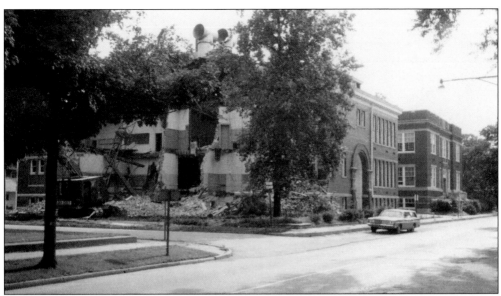

When the 1954 Noblesville High School was completed, the Conner Street location was converted to a junior high school. In 1968, a new junior high was constructed on Field Drive, eliminating the need for the Conner Street facilities. As the school board made plans for the new junior high school, the Boys Club of Noblesville approached the board about the Conner Street buildings. After months of discussions, school officials agreed to lease the gymnasium facility to the organization with one major condition: the 1900 high school classroom building had to be demolished. Looking northeast, the photograph above shows the former high school and gymnasium as the high school was demolished in 1969. Below, the ongoing demolition has not yet reached the second story connector that students used to travel between the buildings. (Both, Irv Heath.)

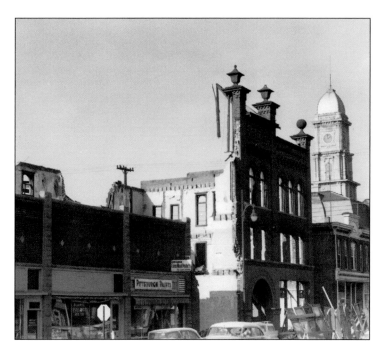

In 1959, the Noblesville Parking Corporation decided to demolish the Wild Opera House and create a public parking lot on the site. Sturdy construction made the demolition difficult, however. Although attempts began in October, it was December of that year before the structure finally came down. Fire had to be set to the timbers, and the brick walls, four layers deep, were pulled down. Debris from the structure is said to lie under the parking lot. (Irv Heath.)

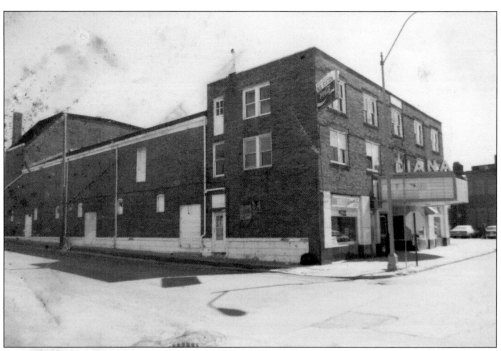

After the Diana Theater closed in 1978, the building served as the loan center for American National Bank. This photograph shows the building before it was completely gutted and renovated by the bank. In June 1993, the building was demolished to make space for a parking lot and an automated teller machine for Society Bank, which had bought American National. (HEPL.)

The ABC Drive-In on Cumberland Road was enjoyed by Noblesville residents for over 40 years before it closed in 1996. In this image of the marquee sign, the word "closed" appears instead of a movie title. The drive-in was torn down to make room for C & E Rental and Service, which is now Sunbelt Rentals. One of the last outdoor picture shows at the theater was *Independence Day*. (Dottie Young.)

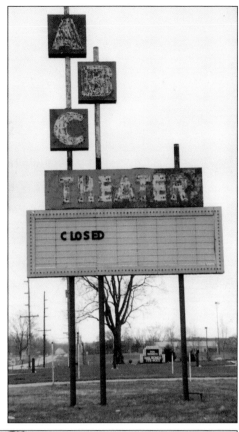

After 34 years of providing entertainment, the Rainbo Roller Skating Rink at the corner of Cumberland Road and Conner Street was demolished in the summer of 1989 to make room for the CVS pharmacy and Hardee's Restaurant. The loss of the rink is still felt by those who skated to music on its hardwood maple floor. Its advertisement, "skate for health—eat for pleasure" is now but a memory. (Dottie Young.)

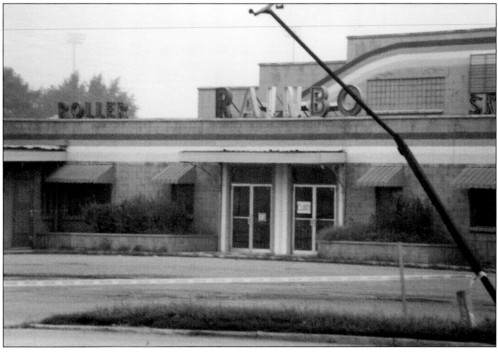

The First Christian Church constructed this wood-frame dwelling as a parsonage in 1913. The home included a "sleeping porch" and was equipped with electric lights and city water. It was used as the church parsonage until the 1970s, when the home was demolished for church expansion. The home is just one of many simple vernacular homes lost to demolition as Noblesville has grown and developed. (First Christian Church.)

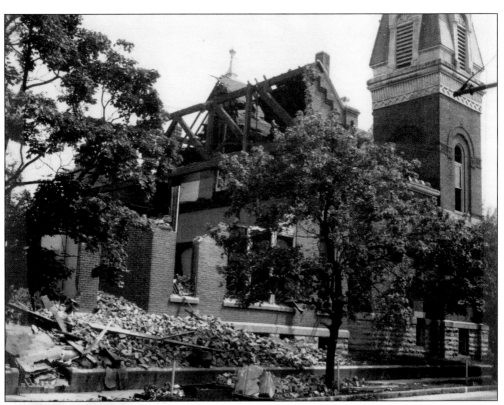

The third brick building constructed by the First United Methodist Church on the corner of Clinton and Tenth Streets was razed in 1964 to make way for a drive-in branch of the American National Bank and a parking lot. Most of the stained-glass windows and fixtures were removed first. The adjacent parsonage was also razed. (Irv Heath.)

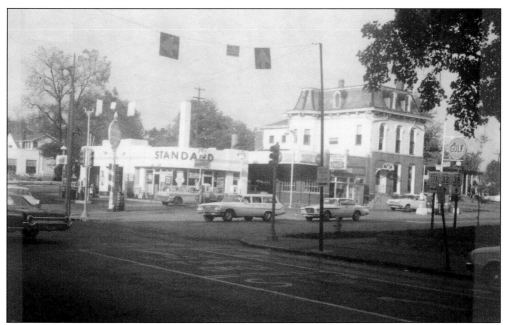

The three-story home in these photographs was located at 1034 Conner Street and was described in 1963 as a "familiar landmark." Its familiar presence, however, has long since disappeared, as the home was razed in 1963. Reflecting the Second Empire style, the home was built around 1870 by William H. Ritchey and was likely one of the premier homes in Noblesville at the time. Its style is rare in the city, which blossomed during the Queen Anne architectural period. The home was operated as a rental property by the Craycraft family for about 40 years; in 1922, it was purchased by Harley W. Forsythe. Forsythe's alterations to the home included a garage addition on the west side. The Forsythes lived here until they sold the property to Standard Oil Company, which then demolished it. (Both, Irv Heath.)

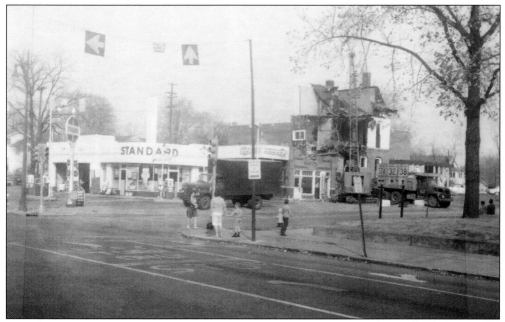

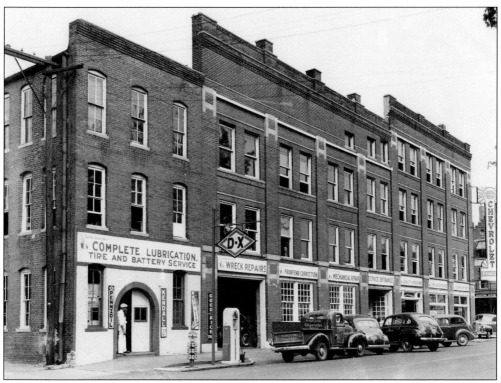

As their business grew between 1948 and 1958, W. Hare & Son gradually relocated to South Tenth Street. For a period of time, a side business known as W. Hare & Son Appliances was located here at the southwest corner of Tenth and Conner Streets. Wainwright Bank, which occupied an adjacent building, eventually purchased and demolished this historic structure in 1981 to construct a large parking lot for the bank. (Hare family.)

After serving as a hospital and nursing school, this facility was sold in 1914 to Hamilton County for $30,000. When the Hamilton County Hospital moved to the Federal Hill area in 1951, the Hamilton Building was used as an office and apartment building; it was razed in 1975 by American National Bank to make room for a parking lot. (HCHS–Roberts Collection.)

BIBLIOGRAPHY

Beck, Anita. *United Methodist Women*. Noblesville, Indiana: self-published, 2012.

Campbell, Frank S. *The Story of Hamilton County Indiana*. Noblesville, Indiana: self-published, 1962.

First Christian Church. *A Journey of Faith in the Hoosier Heartland, A History of the First Christian Church, Noblesville, Indiana, 1834–1999*. Noblesville, Indiana: First Christian Church, 1999.

First Friends Church. *Centennial History of First Friends Church, Noblesville, Indiana, 1890-–1993*. Noblesville, Indiana: First Friends Church, 1993.

First Presbyterian Church's Historical Committee. *History of the First Presbyterian Church of Noblesville, Indiana*. Noblesville, Indiana: First Presbyterian Church, 2001.

Gadski, Mary Ellen. *Hamilton County Courthouse & Sheriff's Residence & Jail*. Noblesville, Indiana: Hamilton County Historical Society, 1994.

Haines, John F. *History of Hamilton County Indiana, Her People, Industries and Institutions*. Indianapolis, Indiana: B.F. Bowen & Company Inc., 1915.

Hamilton County deeds and court records. Noblesville, Indiana: Hamilton County government, 1820s–1960s.

Hamilton East Public Library vertical files. Various years.

Helms, T., editor. *History of Hamilton County, Indiana with Illustrations and Biographical Sketches of Some of Its Prominent Men and Pioneers to Which are Appended Maps of Its Several Townships*. Chicago, Illinois: Kingman Brothers, 1880.

Hill, Fred R. *The First Methodist Church, Our One Hundred and Twenty-fifth Anniversary Program, 1828–1953*. Noblesville, Indiana: First Methodist Church, 1953.

Newspaper Archives Database. www.newspaperarchive.com

Noblesville City Directories. Noblesville, Indiana: Robinson, 1916–1961.

Noblesville Daily Ledger. Noblesville, Indiana: various years.

Noblesville High School. *Shadow Annual*. Noblesville, Indiana: various years.

Noblesville School Board records. Various years.

Shirts, Augustus Finch. *A History of the Formation, Settlement and Development of Hamilton County, Indiana, from the Year 1813 to the Close of the Civil War*. Noblesville, Indiana: self-published, 1901.

DISCOVER THOUSANDS OF LOCAL HISTORY BOOKS FEATURING MILLIONS OF VINTAGE IMAGES

Arcadia Publishing, the leading local history publisher in the United States, is committed to making history accessible and meaningful through publishing books that celebrate and preserve the heritage of America's people and places.

Find more books like this at
www.arcadiapublishing.com

Search for your hometown history, your old stomping grounds, and even your favorite sports team.

Consistent with our mission to preserve history on a local level, this book was printed in South Carolina on American-made paper and manufactured entirely in the United States. Products carrying the accredited Forest Stewardship Council (FSC) label are printed on 100 percent FSC-certified paper.

MADE IN THE USA